Don McCullin
A Retrospective

The British Council

TOUR

Russia, Moscow
The Union of Photojournalists Gallery
March/April 1993

Czech Republic, Prague
Manes Hall
May 1993

Romania, Bucharest
The Exhibition Hall, Office of Exhibitions
June/July 1993

Bulgaria, Plovdiv
City Art Gallery
August/September 1993

Slovakia, Kosice
Galeria Jakobi
October 1993

Poland, Lodz
Gallery Rezydencji Ksiezy Mlyn
November/December 1993

Hungary, Budapest
Ernst Museum
February/March 1994

An exhibition organised by the Royal Photographic Society, Bath and toured through the British Council

Published by The British Council
10 Spring Gardens
London SWIA 2BN

Produced by the Visual Arts Department on the occasion of the tour of the Don McCullin exhibition in Central and Eastern Europe

Exhibition Officer: Brett Rogers
Exhibition Assistant: Joanna Gutteridge
Editor: Dr Michael Murphy

ISBN 0 86355 207 2

Catalogue designed by Tim Harvey
Printed by Gavin Martin Associates

Front cover: catalogue no.94
Back cover: catalogue no.92

FOREWORD

Mention the name Don McCullin to a certain generation of Britons, and many can still vividly recall the experience of opening their Sunday Times magazine in June 1968 to be confronted by McCullin's coverage of the horrors of famine in Biafra. Twenty five years on, these images still retain their unequivocal visual and emotional power.

From the moment when Don McCullin's photographs were first published in the sixties, their impact was to transcend space and time. Through syndication to other papers and magazines abroad, McCullin's harrowing images of war, global famine and human atrocity, reached an audience which extended beyond Britain and into the heart of Europe. Whilst many of his works are well known through reproduction, the present exhibition provides the first opportunity for audiences in Central and Eastern Europe to appreciate the distinctive graphic qualities of McCullin's photographs. All the works in the exhibition have been specially printed for this exhibition by the photographer himself. We are extremely grateful to Don McCullin for his close interest in and enthusiasm for this tour and the Royal Photographic Society who originally mounted this exhibition at their own gallery in Bath, in 1991. We have particularly valued the involvement of Amanda Nevill, Secretary of the Royal Photographic Society and Carole Sartain, Exhibitions Officer in all aspects of the planning and preparation of the tour and Pam Roberts, the exhibition selector, who in addition to curatorial guidance has provided us with a personal account of McCullin's life and work.

Brett Rogers
Exhibition Officer
Visual Arts Department

Muriel Wilson
Head
Visual Arts Department

Pam Roberts
Curator of the Royal Photographic Society, Bath

WAR AND PEACE

Don McCullin is one of the most interviewed figures in the history of photography. Unlike many of his contemporaries, he has been cross-examined frequently on his photography, humanity, morality, and private life.

In 1990, at the relatively early age of 55, he gave in and made it easy for future interrogators, organising his stories, memories and emotions into a neat, indexable form in the shape of his autobiography *Unreasonable Behaviour*. A compelling and brutally truthful book, it traces thirty years' experience of war, death, inhumanity, conflict, fear and tension, with very little in the way of any light relief. Yet, at the end of this narrative, which could easily have been shared out among ten people and given each of them enough material for a gripping autobiography, we are left with a

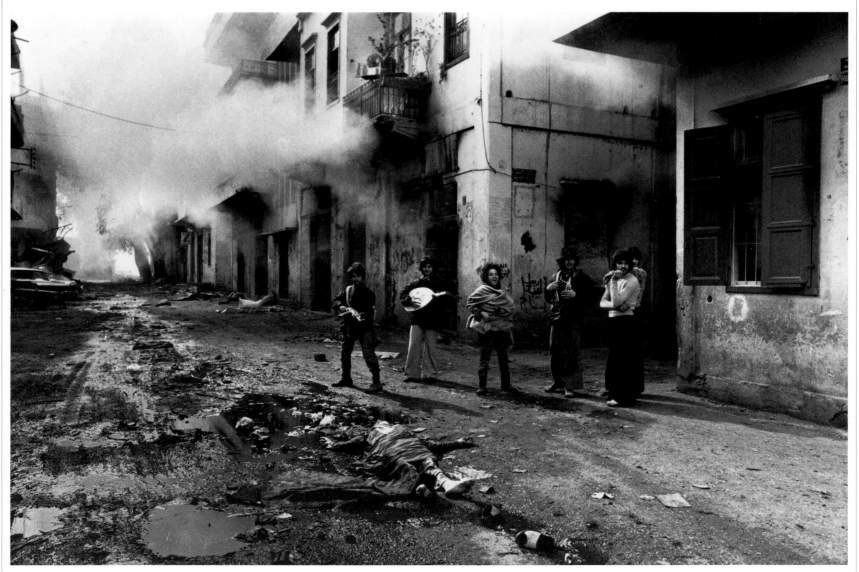

35. Quarantina, Beirut, 1975. Christian militia mock the body of a dead girl killed in the battle of Quarantina

4

strong feeling of catharsis. As readers, we feel that we have vicariously experienced tragedy, pity, fear and horror, albeit at someone else's expense, and have somehow been purged and purified through the encounter. It was a device not unknown to Shakespeare but, unlike Shakespeare's heroes, our main character does not suffer hubris but lives to tell the tale.

Why should anyone seek out these situations, fraught with both physical and psychological pain? Why should anyone choose to spend their life observing man, the epitome of God's creation, showing the depths to which he can sink? The answers to these questions seem to vary according to the different stages of McCullin's career.

In 1959, after the acclaimed publication of his photographs of the North London street gang 'The Guv'nors' in *The Observer*, he was suddenly thrust into an unplanned career in photojournalism.

At a stroke, it provided the possibility of a regular salary, the fuelling of ambition, and the opportunity for some macho bravado. More importantly, however, came the discovery that photography could not only be the entrance to the sort of life he wanted, but was also something at which he appeared to excel.

"I was given the opportunity. I created my

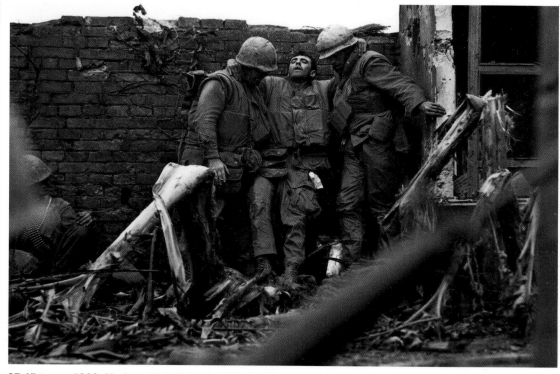
65. Vietnam, 1968. Marine with bullet wounds in both legs being supported

life. As soon as the doors were open... they're not open for ever... I was in there. I liked what I saw, then. I took my coat off and rolled my sleeves up and had a go".

From an underprivileged background, McCullin suffered from the deficiencies of lit-

tle formal education, dyslexia (not then known as such), a fragmented childhood as an evacuee and a life hovering on the edges of violence and criminality. However, he soon discovered a visual intellect to compensate for the academic training he felt he lacked.

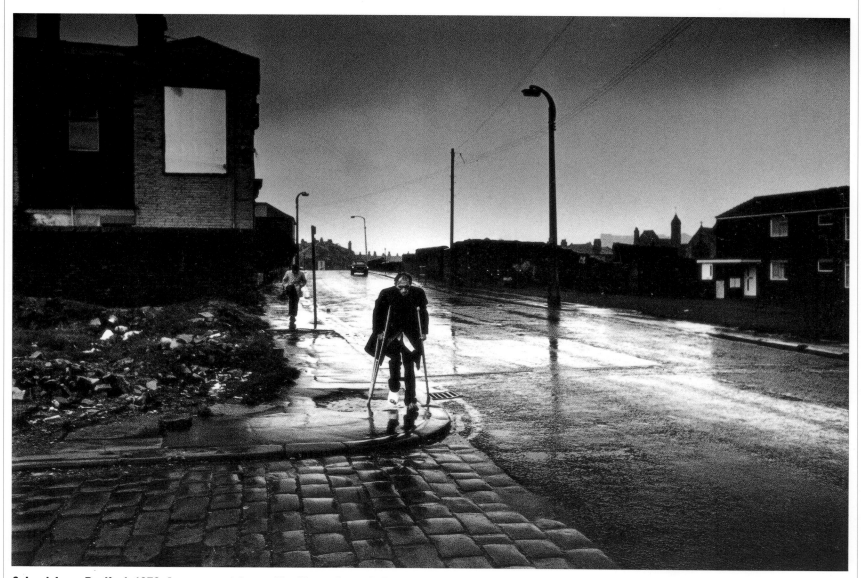
6. Lumb Lane, Bradford, 1978. A man on crutches making his way home during a winter rain storm

Photographing the trouble spots, the action and the conflict in the world, supporting the underdog in his fight for freedom and democracy against oppression became initially an escape, a complement to the violence within himself and then, an obsession. Eventually it became an addiction and a habit that had to be kicked. "Photography is like an illness. It's like the promise of a tremendous high and the promise of an incurable disease".

By 1965, McCullin was working for *The Sunday Times* magazine, at that time the Sunday supplement committed to carrying photographic essays of the most uncompromising kind. Sunday breakfast was not an easy time to digest the Times' hard-hitting photographic coverage of war, starvation and stoically endured misery.

McCullin was always in the eye of the storm, always working in the conscience spot of the world. He had already covered war in Cyprus, the Congo, and Vietnam for *The Observer*, but was also required to cover lighter domestic stories such as nudist camps. Frustration with the paucity of serious material led to his move in 1965 to *The Sunday*

hand in glove. When you go to war, you see acts of beauty that you couldn't imagine could squeeze themselves in between the sheets because the ugliness is on such a grand scale. But, lying under a barrage of gun fire, suddenly, you'd look up and see groups of tropical birds flying over and you see a man cradling another man, like one of Julia Margaret Cameron's cradling the child. They are not moments of beauty that some people would have time to recognise but, someone like me, who was there all the time gleaning the daily panorama of agony and misery and tragedy, would spot these things as my eyes are trained to search out and see almost everything. Things like this are not difficult to see. But sometimes you don't want to see everything".

During the 1970s, McCullin had begun to broaden his photographic coverage turning his attention to the social conditions afflicting his own country. He also published several books, such as *The Destruction Business* (1971), *Homecoming* (1971) *The Palestinians* (1979), culminating in 1980 with *Hearts of Darkness*. Its publication coincided with artistic recognition, in the form of a major

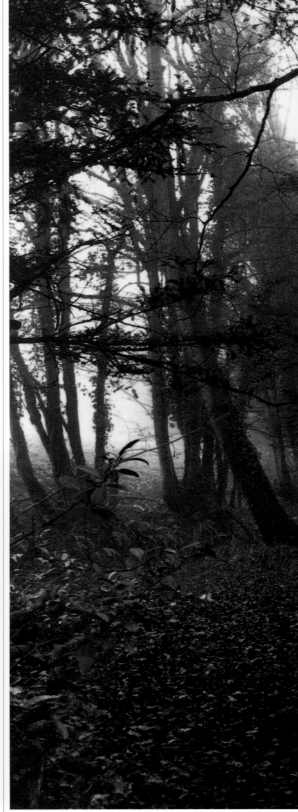

127. Conservation area, Somerset

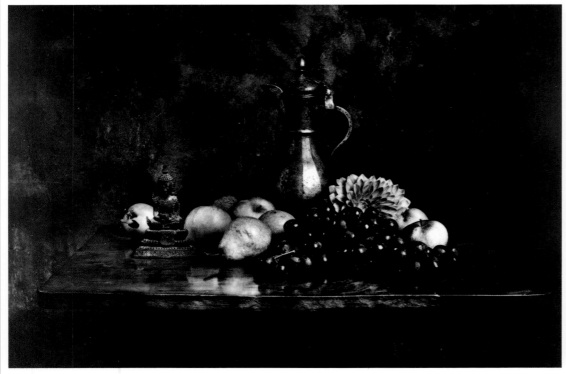

112. Still life, Cambodian Buddha

Telegraph magazine, which proved to be even more restrictive in the subjects it allowed him to cover.

McCullin's years at *The Sunday Times* had enabled him to cover important events such as the Six Day War and to travel extensively to many countries including Cambodia, Jordan, India, Papua New Guinea, Northern Ireland, Uganda, China, Beirut and El Salvador. Over the next 18 years, McCullin seemed to be present at every war, every famine, every uprising, every scene of conflict. He was greedy for visual satisfaction.

"My eyes were like a hungry belly, gluttonous for detail... Beauty and the beast do go

exhibition at the Victoria and Albert Museum, London.

But then things began to go wrong. The refusal of the Ministry of Defence to let him accompany the Task Force to the Falklands angered him intensely. He had covered war in every other country but was not allowed to cover it for his own. He was also shaken by the reaction in Beirut of a woman, crazy with grief after an explosion had killed her entire family. She attacked him when he photographed her, unusually for him, without her permission. The woman herself was killed soon after. It seemed like a watershed. Events began to pile up.

Personal Conflicts, Changing Styles
Redundancy from *The Sunday Times* in 1983, which, under the editorship of Andrew Neil and the influence of the yuppie 1980s had metamorphosed from the flagship of photojournalism into the lifestyle and leisure handbook for the rich consumer, took away a regular source of income. McCullin describes himself in 1983 as "a middle-aged, out of work photojournalist without prospects". The consumer was king, and apparently no longer wanted truth with his Sunday croissant. Black and white reality gave way to full colour narcissism, although a few years later, public response to the famine in Ethiopia and the

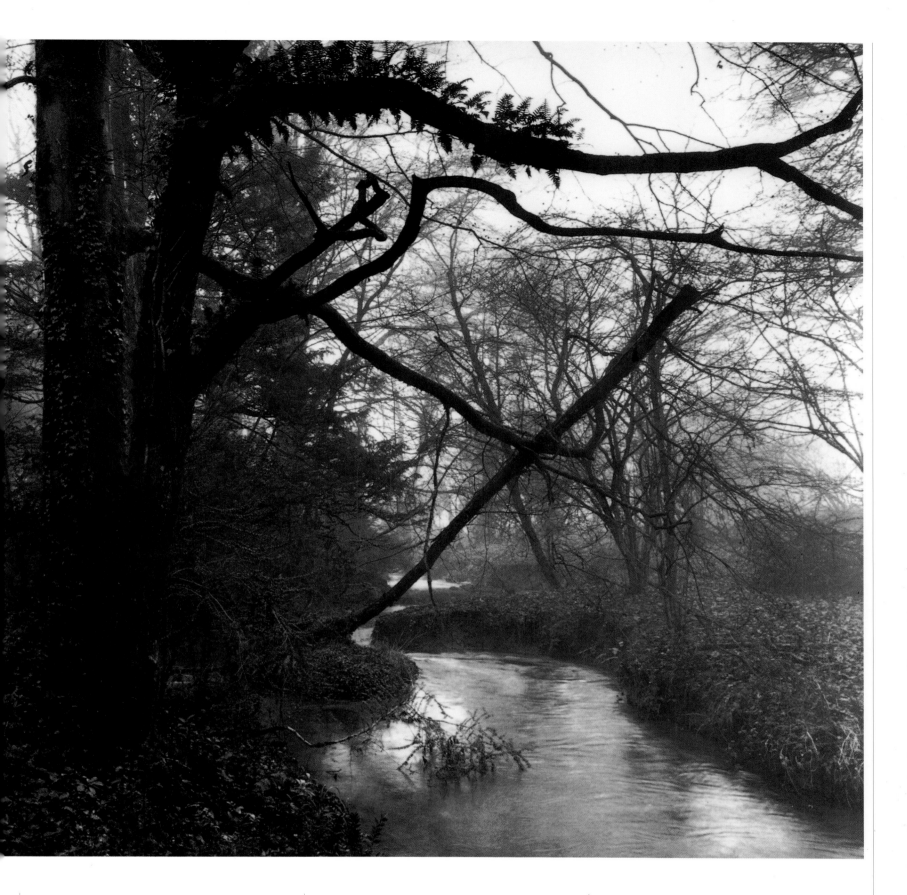

success of *The Independent* newspaper (launched in 1986) proved that the public were not as fickle as first thought, and that there was a place for photography that went out and captured the truth.

McCullin lost his job and his marriage, and was forced to take advertising work, which he loathed (and still does), to pay the bills. His ex-wife died, painfully, of cancer. A relationship which had broken up his marriage fell apart and he was left, alone, mentally and physically scarred and economically shaky. Strength came, as it always had, from photography. McCullin had begun to photograph landscapes and still lifes earlier in his career,

but now these became his prime subject matter. Living in relative isolation in Somerset, he immersed himself in photographing huge panoramas within walking distance of his home.

These dark and moody landscapes, full of Biblical light – the visual equivalent of descriptive passages from Thomas Hardy – are like all of his work, concerned with conflict. His preference for photographing on stormy days in winter resulted in landscapes of broody romanticism. On the occasions when the camera captures the detail of the landscape itself, rather than observing from a distance, there is a gentler, more pictorial and

mystical feel to the photographs, almost an element of the magical. His still lifes, taken mostly in his kitchen, are an exploration of light, texture and composition, using familiar objects in domestic settings. The mood of these photographs is a long way from those made in Vietnam and Biafra.

McCullin's travel over the last few years has often taken him to India and, in these photographs, a new quality of gentleness replaces the former "fist-like black and white". The characteristic confrontational style of early years has mellowed into a more benign vision. The camera is pulled back and observes, with humour and affection, the interaction of peo-

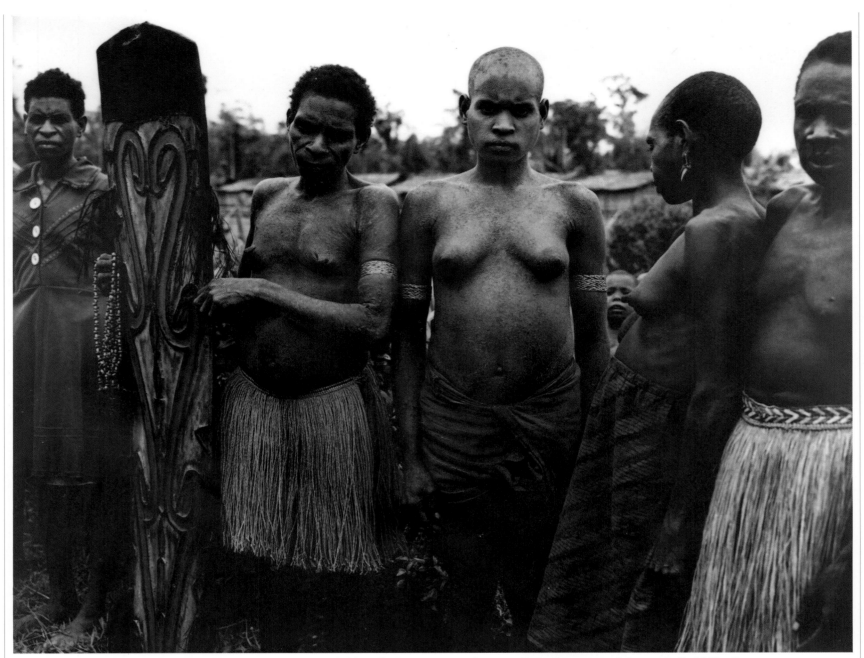

152. New Guinea, 1985. The Orangs, of the Irian Jaya, the most primitive tribe known to man. Once cannibals, they are now being gradually 'civilized'

ple, river and elephants. "I was just photographing gatherings of people, the simple Indian peasantry, that I shall do for as long as I can keep it up financially and physically. I go to a place where there's half a million people and I bed down with them and, as yet, I haven't taken any really remarkable photographs. Sometimes, photography defeats you. You can see amazing things and you get so excited and when you get the camera out and you take some pictures, only now and again, you get a nice picture. If I can add one picture from now on for each year that's beautiful or nice or that people really like, then I'll be doing all right. All that war and stuff, it's gone. I feel that the man that did that was another person even though I know who it was, it was me. I just want to go quietly into the field with my camera and take landscape pictures".

A humanistic creed

Over the years, McCullin has sought to express through his photography, a concern for the ecological and human fate of the world. He considers his photography is about raising people's awareness, being their representative at the site of conflict and reporting back what is happening. Although McCullin claims to be a pessimist, his creed is in fact that of an optimist, since photography is something he continues to do, despite the fact that results are slow in coming, and inhumanity still persists.

McCullin has always preferred to be in the centre of things, exploiting the scrutiny provided by a low camera angle. The people he chooses to photograph are isolated in a timeless, unidentifiable place, be it Vietnam or Biafra, but in reality, are innocent victims of violence. Their only volition comes from external forces like war, famine, genocide.

Character studies of displaced peoples with nothing but utter hopelessness to look forward to, should be depressing and pessimistic. Yet in most of them, innate dignity is preserved. They face the camera, having lost family and home, possibly in physical pain, and are accorded a great sense of beauty through dignity. McCullin's camera could do nothing

worse to them and by photographing them, they are seen to exist and their plight realised. He also feels, to some extent, that he has suffered with them, that their griefs are equal and that they are mourning the same losses.

In his latest landscape work, McCullin, the photographer who once said all his work was about people, has now pulled his camera back and given himself huge open spaces to fill. There are no people and only the occasional animal. His landscapes deal less with Nature's ordered harmony than with the destruction of the English countryside, with discord and confusion. Again he is recording it to prove its existence before it too is swallowed up by development. "Now I take photographs to please and have changed gear. I was in top gear and I'm no longer in full flight. My wings don't do so many flaps. I'm getting slower but bigger, hopefully getting more peaceful".

Control over Quality

McCullin has a sturdy sense of humour and is neither dour nor taciturn. There is a great sense of shyness, humility and an air of worry

about him. "Worry has played a major role in my photographic life, about materials, and fear at the battle front".

He holds himself in balance and compares himself to an ex-alcoholic. "I'm an addict who is trying to cure himself and is weak. I'm like an alcoholic who's given up drink and who's been invited to a huge wedding breakfast. I'm looking at other people drinking and I'm shaking". He imposes a strict regime of orderliness, tidiness and routine, qualities needed for the darkroom. McCullin is obsessive about print quality and about control of his negatives. Unlike Picture Post photographers in previous decades, he has always held on to his negatives and is fastidious about their handling. Apart from the obvious sound conservation and economic aspects of this, the safety of his negatives seems to exert an almost talismanic effect. Whilst at *The Sunday Times* he had total editing rights to his own material and could insist that nothing was cropped without his permission and always laid out as he directed. No one else was allowed to make his negatives tell a different story. Many of his 30-year-old, 35mm negatives are still printable despite hasty and incomplete processing at the time.

McCullin feels that, as he risked his life for these photograph, always checking exposure, and framing the best shot he could in the face of extreme danger, and limited visibility, spending more time than was desirable making himself a target in the face of possible impending death, he has an obligation to make sure that they endure. He also owes it to his subject matter to do the best he can to have his work treated as something of importance rather than as ephemeral. He tells stories of being under fire, of colleagues being killed and wounded all around him, his own life in imminent danger of extinction, whilst his main concern is for the roll of exposed film that somehow, falls out of his top pocket. That loss obviously still rankles 20 years later. He still wonders about the shots on that roll.

The obsession with protecting his negatives also extends to print production. Sleep is difficult the night before printing, the task before him so daunting and still terrifying. Unlike many photographers of his stature, he prints every image himself. Many of his recent prints have been printed at 20 x 16in on 20 x 24in Agfa Portriga paper and every minute mark painstakingly retouched. It is a draining job, as McCullin pours so much energy and feeling into it. Many of the photographs for his 1988 book *Open Skies* were printed after he had heard of the terminal illness of his ex-wife. The anger and chaos that he was feeling at that time are apparent in the passionate strength of the printing, what McCullin has called his "fist-like black and white prints" which truly punch their power home. He hates to waste materials. Three months of landscape work was ruined when McCullin discovered

the camera back had put a hairline scratch across every film. He had not made contact prints, not wishing to touch the negatives unnecessarily until the time came for printing.

Wasting paper similarly upsets him, "one of the most awful things that I try to put at the back of my mind but I can't, as I feel guilty about it". This attitude is not brought about by meanness – although the materials he uses are undoubtedly expensive – but by the sanctity, to him, of the whole process. He talks

He has often forcefully said he will never photograph war again but was itching to get out to the Gulf in February 1991. "If anyone was to be there at the front photographing, it should be me because I've got the knowledge, hopefully, of how to stay alive, how to take those kind of pictures". But the censorship during the Gulf War, whereby all photographers' films were handed in every night to a central monitor, infuriated him. "One reason I'm not there is because I don't want to be

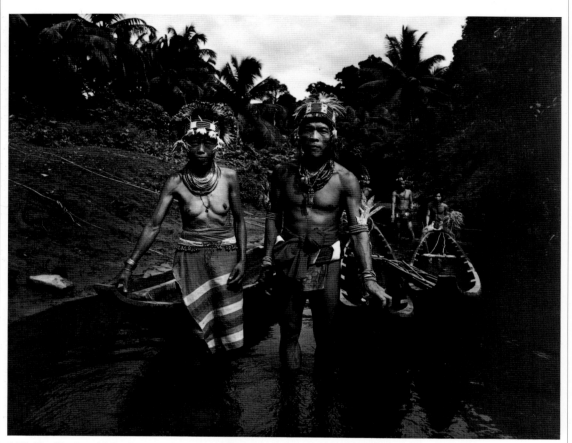

140. The Mentawei Islands, near Sumatra, 1987. The festival of the new canoes

of photography as blackmail. "You are striving for freedom. Photography is something you really don't own. You just borrow from the gods. So, you are always trying. It's always blackmailing you. It's the only form of blackmail that I'll put up with, photography. If it was any other form of blackmail, I would really fight against it, but with photography, you don't even begin to fight it."

McCullin is a mass of contradictions. He claims he finds it difficult to talk about his photography, yet talks about it very lucidly, "The trouble is, when you take one or two good photographs which have an impression on someone, people expect it to be backed up by philosophy as well. Why you took it and all that kind of stuff, and it's unnecessary. You took it because it presented itself and you took the photograph. That's all that needs to be said about it other than to give some vital information about what's going on in the photograph. I can give more by doing, by photographing, than I can by talking because my spectrum, intellectually, is very narrow, but, photographically, it's incredibly wide...".

involved in a system like that. If I'm going to risk my life, I want to be respected and not treated like an idiot. I got fed up with all that lying and cheating".

McCullin is the man who hates to carry a camera – he pawned his first camera for the deposit on a motorbike: "If I could interpret it through my mind onto a sheet of paper without my camera equipment it would be wonderful" and "I hate carrying cameras, they disfigure me. I carry a conscience". He is also the man whom the camera liberated. The camera gave him his eyes and his soul, his misery and his joy. It took him to places that scarred his mind and his body. It has unbalanced his life and, at the same time, given him a powerful reason for living. As we look at a tiny percentage of the images that one man saw through his camera lens, we should be thankful that he was there, and not us.

McCullin once said that all he had ever done, and liked, was in the past. He has recently said that he wants to concentrate on the present and the future. Maybe he is finally reaching perfect equilibrium.

CHRONOLOGY

1935, 9th October
Born in London, eldest of three children

1940–44
Evacuated from war-time London to Somerset and Lancashire

1944–45
Attended Finsbury Park Primary School, North London

1945–49
Attended Tollington Park Secondary Modern School, London

1949–50
Awarded Trade Arts Scholarship for drawing ability at Hammersmith School of Arts and Crafts, London
Father died of bad chest condition after a lifetime of asthma.
Left art school to find employment

1950
Worked as a dining-car attendant, British Rail

1951–52
Worked as messenger at Larkins Cartoon Studios, Mayfair, London

1953–55
Underwent National Service.
Served as a

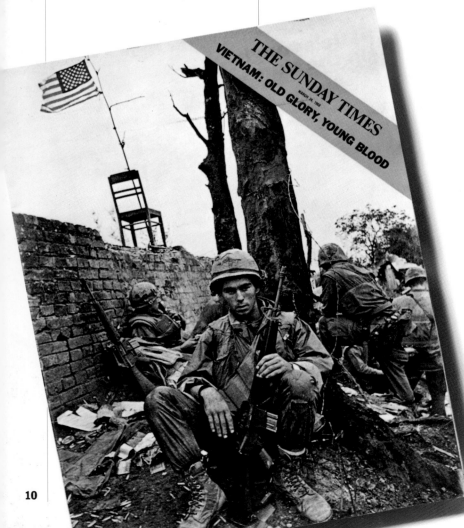

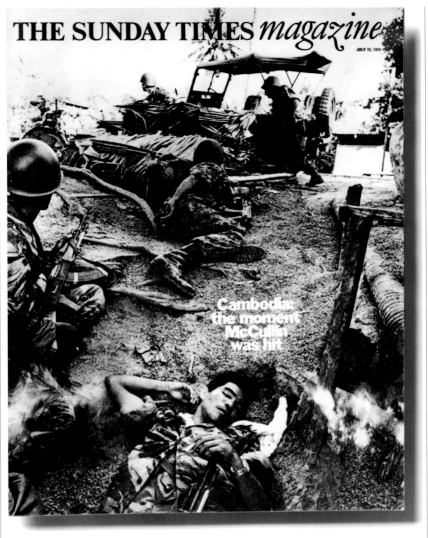

photographic assistant in aerial reconnaissance in the Royal Air Force, Oxfordshire, Suez Canal Zone, Egypt, Cyprus and Kenya. Work involved developing and printing 3000 photographs a night. Failed photography trade test. First camera, a twin reflex Rolleicord, bought for McCullin in Aden by a friend for thirty pounds

1956–59
Returned to Larkins Cartoon Studios, copying line drawings. Pawned Rolleicord for five pounds (his mother later bought it back for him)

1958
Photographed local street life in Finsbury Park and members of street gang "The Guv'nors". Murder of a policeman by a rival gang led McCullin to take photographs to *The Observer* who bought them for fifty pounds and published them on 15th February 1959, thus beginning his career in photojournalism

1959
Married Christine Dent, with whom he subsequently had three children

Left Larkins. Started work as a freelance photographer for the *News Chronicle* and *Town*, as well as *The Observer*.
Begins to make contact with other photographers and to use Pentax camera

1961
Travelled (uncommissioned) to Berlin and sold resulting photographs to *The Observer*. Received UK Press Photography Award

1962
Worked as freelance photojournalist for *The Observer* (two days per week on a fifteen guineas a week retainer). Stories covered included Berlin, Cyprus, The Congo, Yemen, Vietnam and social conditions in England. Also freelanced for *Town*, *Paris Match*, *Stern*, *Life*, *Illustrated London News*

1964
Offered first war assignment in Cyprus by *The Observer*
Awarded Warsaw Gold Medal and World Press Photographer Award (first ever given to a British photographer)

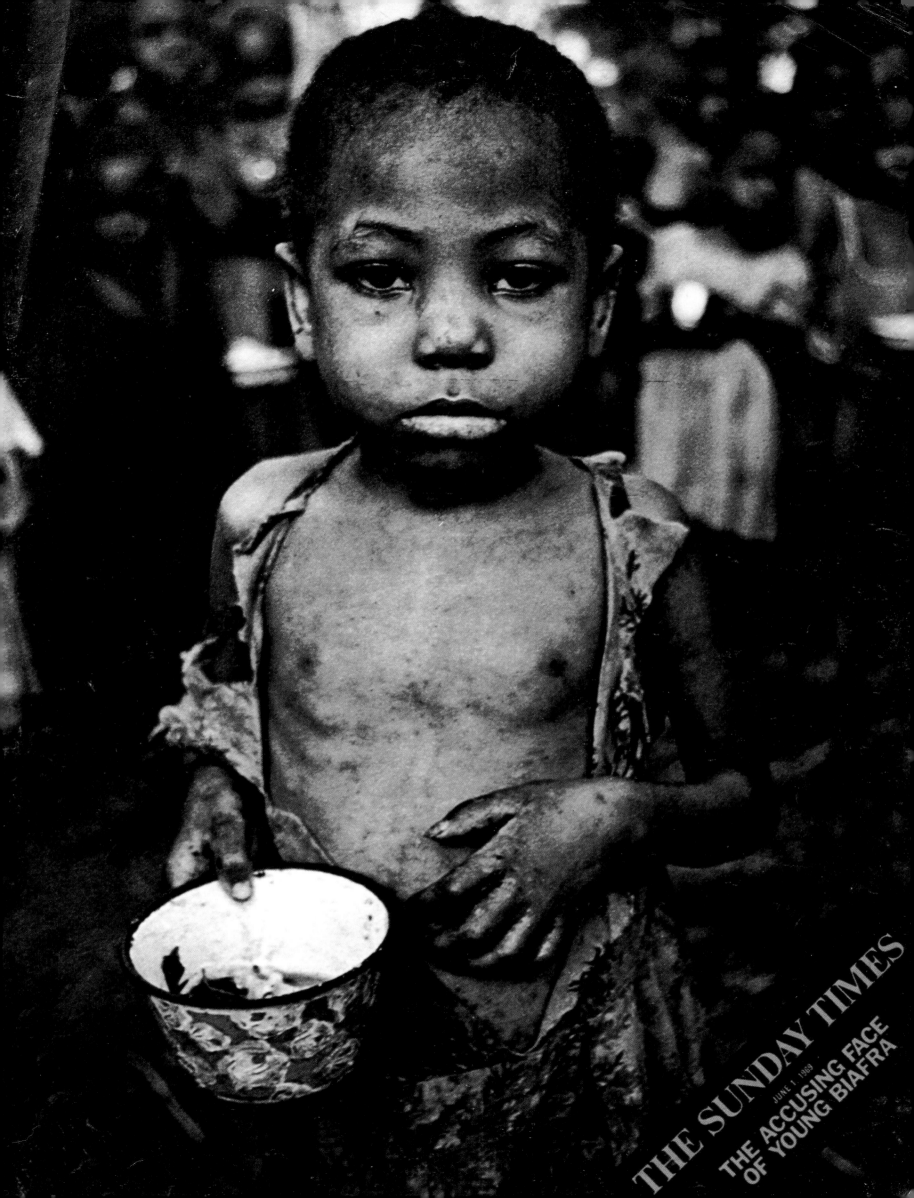

THE SUNDAY TIMES
JUNE 1, 1969
THE ACCUSING FACE
OF YOUNG BIAFRA

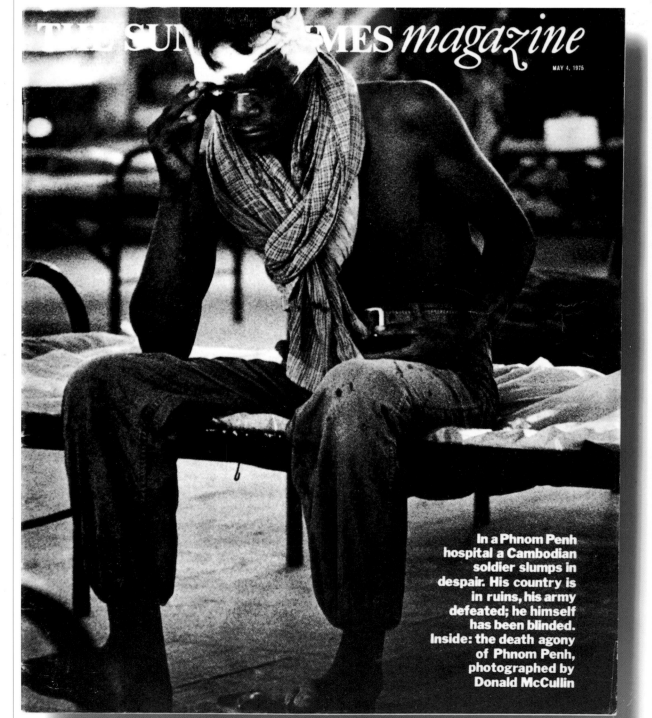

1971

Guatemala; famine, cholera and civil war in Bangladesh; Northern Ireland
Published first book *The Destruction Business* (Open Gate) containing foreign and British photographs. Offered first exhibition *The Uncertain Day* at Kodak Gallery, London. Published second book *Is Anyone taking any Notice?* (MIT Press, Cambridge, Mass.) Text from Alexander Solzhenitsyn's 1970 Nobel Lecture

1972

Vietnam; Mauritius; Iceland; China
Jailed in Makindye prison whilst covering Ugandan uprising and then deported from Uganda. Exhibited in *The Concerned Photographer II*, organised by the International Center of Photography, New York.

1973

Cambodia as the Khmer Rouge move in; famine with the Tuaregs; Japan; down and outs in London; Israel

1974
New editorial policy on *The Sunday Times Magazine* leads to McCullin having to cover more local and European stories such as **Algerian immigrants in Marseilles; Consett, Durham; Hadrian's Wall**

1975

The fall of Phnom Penh to the Khmer Rouge; Paraguay (with Norman Lewis); Angola; civil war in Lebanon; the massacre of the Palestinians in Quarantina
Almost killed when he submits a Christian Phalange pass to the Palestinians
Began using Olympus OM-I for reportage

1965-early 1966
Freelanced for *The Sunday Telegraph* newspaper, London

mid 1966-84
Lured away from *The Sunday Telegraph* by art editor, David King, to become a staff photographer for *The Sunday Times*, under the inspired editorship of Harold Evans, covering trouble spots of the world as well as stories in Britain
Over the next eighteen years at *The Sunday Times*, the stories covered included;

1967
Famine in Bihar, North India; Six Day War in Israel; The Congo; Liverpool; slaughterhouses; Montgomery, Rommel and the Desert War; white mercenaries in Africa
Joined Magnum photo-agency as probationary member but declined full membership

1968
Battle for Hue (Vietnam); Czechoslovakia; famine and civil war in Biafra; Cuba (with Edna O'Brien); Yorkshire, the Beatles and American Football

1969
Biafra again as it headed towards surrender; Indians in Brazil; Vietnam; Wigan (North England)

1970
New Guinea; Chad; Jordan; Cambodia
Wounded in Cambodia

In a Phnom Penh hospital a Cambodian soldier slumps in despair. His country is in ruins, his army defeated; he himself has been blinded. Inside: the death agony of Phnom Penh, photographed by Donald McCullin

1976-78
Berlin; poverty in Bradford (Northern England); horse fair in Appleby. Began photographing industrial communities in the North of England for eventual book *Homecoming.*
Began work with Jonathan Dimbleby on a book *The Palestinians*

1978
Awarded Hon.FRPS by The Royal Photographic Society, Britain.

1978-79
Following the closure of *The Sunday Times* and *The Times* because of a prolonged print union strike, McCullin began to concentrate on landscape and British photoreportage

1979
Published *Homecoming* (Macmillan) with text by the photographer
Published *The Palestinians* (Quartet Books) with text by Jonathan Dimbleby

1980
Accorded first major exhibition of 120 photographs at Victoria and Albert Museum, London
Published *Hearts of Darkness* (Secker and

Warburg). Text by John Le Carré. Exhibited *The Palestinians* at Olympus Gallery, London. Commissioned by *The Sunday Times* to cover Mujaheddin in Afghanistan but the story is never used. With purchase of *Times Newspapers* by Rupert Murdoch, profile begins to change

1981
Independence for Zimbabwe

1982
Israeli invasion of Beirut
Injured in fall from a roof in El Salvador
Refused permission to go to the Falklands with British Task Force

1983
Dismissed from *The Sunday Times* after disagreements with new editor, Andrew Neil as to the lack of serious foreign and social coverage
Exhibited *Beirut: A City of Crisis* at Olympus Gallery, London
Included in a travelling exhibition of male portraits *The Sense and Sensitivity of Man* (sponsored by Chanel)

1985
Began to explore

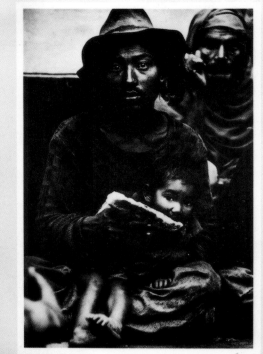

DON McCULLIN
With an Introduction by JOHN LE CARRÉ
HEARTS of DARKNESS

different kinds of photography (such as photographic travel diaries, landscape, advertising and commercial work) using Mamiya camera

1986
Made TV documentary with BBC "Arena" entitled *Homefront*, based on *Homecoming* photographs

1987
Published *Perspectives* (Harrap) covering British reportage.
Divorced from Christine after some years' separation.
Travelled to Mentawei Islands, near Sumatra

1988
Ex-wife Christine dies of cancer

1989
Published his first book of landscapes and still lives, *Open Skies* (Jonathan Cape) with text by John Fowles

1990
Published his autobiography *Unreasonable Behaviour* (Jonathan Cape). Written with Lewis Chester.
Travelled to India to cover religious festivals

and everyday life
Began using Linhoff 5x4" camera

1991
Commissioned by *The Independent* magazine to cover the refugee crisis in Kurdistan. Collaborated with HTV (Bristol) on a two part television documentary on his work. Offered major exhibition (152 works) at the Royal Photographic Society, Bath. Exhibition travelled to National Museum of Film, TV and Photography, Bradford, and Kelvingrove Art Gallery and Museum, Glasgow

1992
Exhibited at Rencontres d'Arles and Toulouse, France.
Published Photo-poche (Centre Nationale de la Photographie, Paris)
Began working on two books (one on India, the other a retrospective of his work) for Jonathan Cape

1993
Awarded CBE in Queen's New Year Honours List
Awarded Erich Salomon Prize for Photojournalism (presented at Museum Folkwang, Essen, Germany on the occasion of his exhibition there)

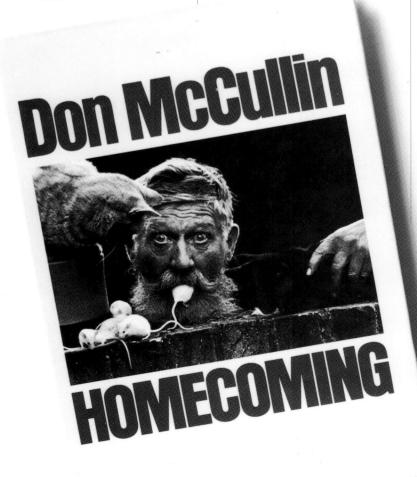

Don McCullin
HOMECOMING

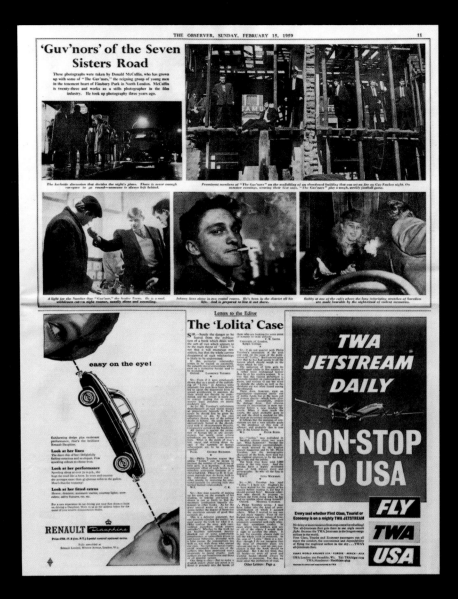

These photographs were taken by Donald McCullin, who has grown up with some of "The Guv'nors", the reigning group of young men in the tenement heart of Finsbury Park in North London. McCullin is twenty three and works as a stills photographer in the film industry. He took up photography three years ago.

Editorial comment. *The Observer*, 15 February 1959

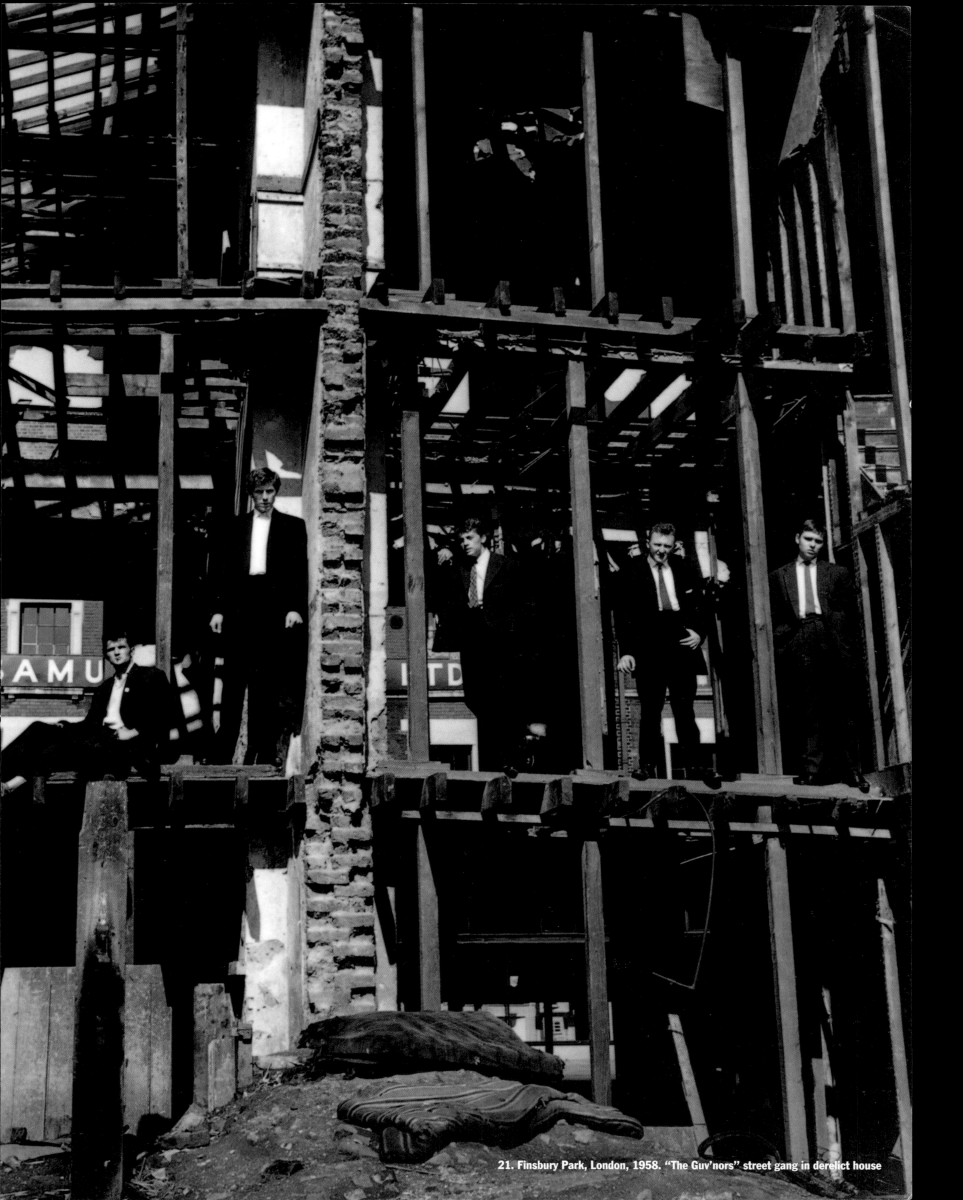

21. Finsbury Park, London, 1958. "The Guv'nors" street gang in derelict house

CRISIS ON SKID ROW

The property developers who are tearing the hearts out of our cities are destroying more than just buildings. At the lower end of the social scale – uncharted except by the charity organisations who work among them – the number of dossers, whose traditional accommodation is disappearing, has grown dramatically. In London alone there are now as many people living on the streets as at any time since the beginning of the century. *James Fox* and *Nicholas Fogg* explain the causes and the disturbing consequences. Photographs, all taken in London's East End, by *Donald McCullin*.

Something calamitous seems to have happened to the economic structure that supported London's dispossessed poor and offered them a cheap refuge from skid row. In the eastern end of London particularly – Southwark and Dockland, for example – the developers' passion for office blocks is breaking up communities and exchanging cheap accommodation for the expensive.

Cheap accommodation in common lodging houses and boarding houses was the last line of defence against the doss-house for the single homeless man or woman. And many people consider that last step down a degrading one. But boarding houses are disappearing – one third of the beds have gone during the past 10 years – and cheap hotels are being upgraded for tourists, students, and travelling businessmen. Even lodging houses founded as charitable trusts, like Rowton House in Southwark, which had beds at 42p for artisans and now charges package tourists £2·65 a night, have fallen into the hands of commercial managements and been upgraded. Casual work on the wharfs and markets is disappearing; sympathetic cafés and pubs ▶ 22

Right: a destitute man sleeps in the derelict Rothschild Buildings, Whitechapel. *Far right:* the meeting place of a corner of Spitalfields Market. Here the dossers find a little companionship

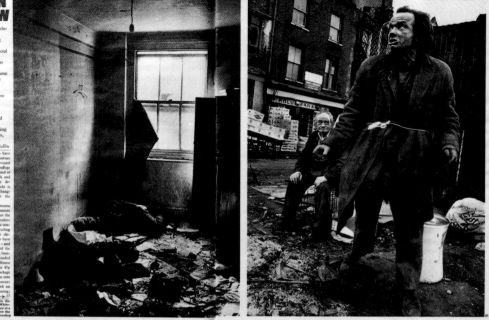

The property developers who are tearing the hearts out of our cities are destroying more than just buildings. At the lowest end of the social scale, the number of dossers, whose traditional accomodation is disappearing, has grown dramatically. In London alone there are now as many people living on the streets as at any time since the beginning of the century.

James Fox and Nicholas Fogg, *The Sunday Times Magazine*, 24 June 197

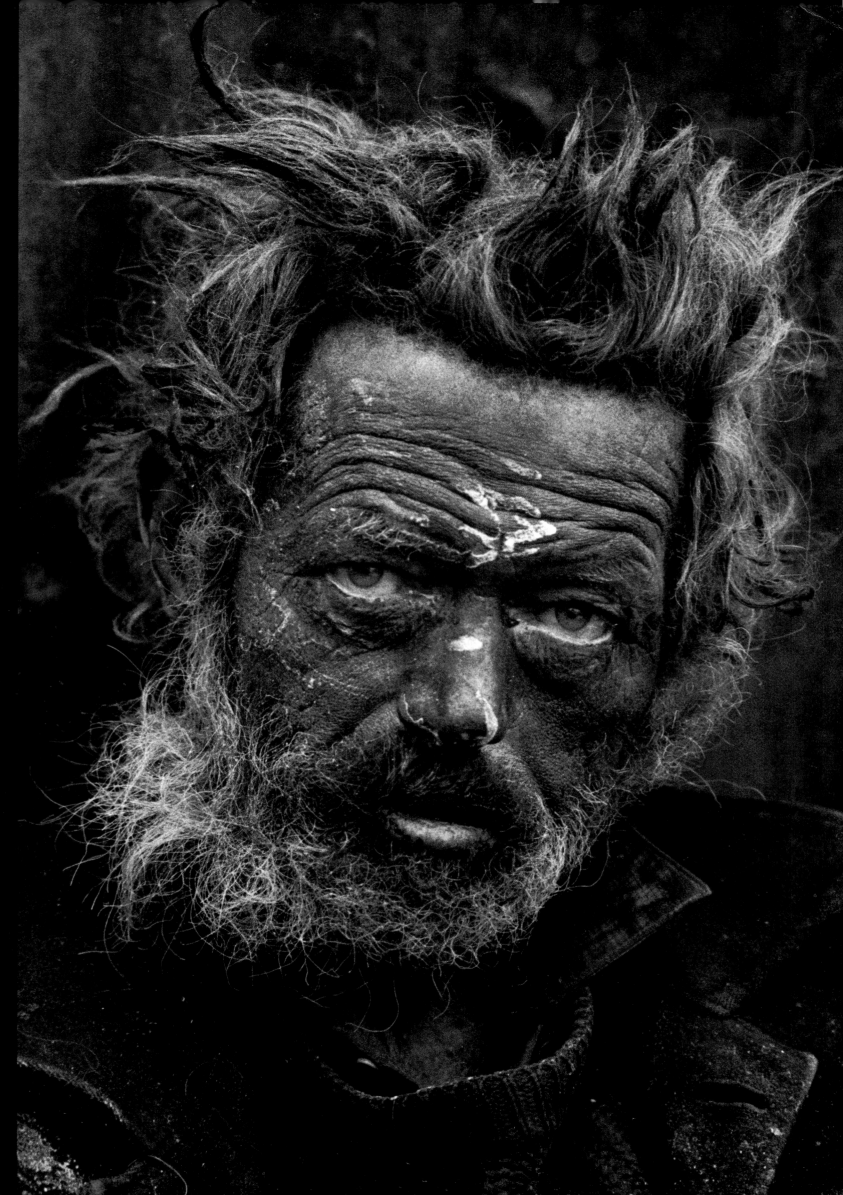

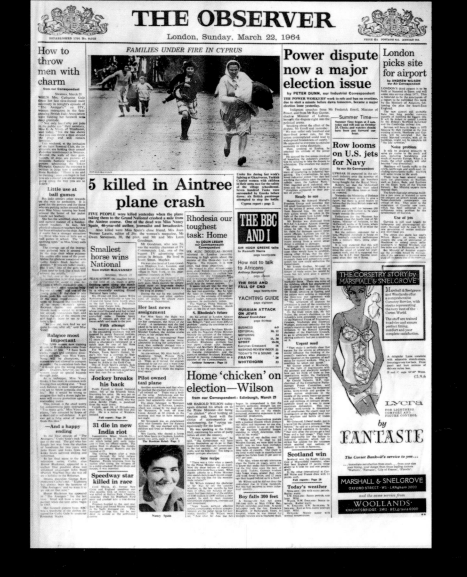

Under fire at last week's fighting at Ghaziveran, Turkish Cypriot women with children in their arms, race for the safety of the village school house.

Editorial comment. *The Observer*, 22 March 1964

I pointed to my hand with the camera in it, asking for an invitation to record the tragedy. An older man said "Take your pictures, take your pictures". They *wanted* me to do it. I was to discover that all Middle Eastern people want to express and record their grief vividly.

Don McCullin. *Unreasonable Behaviour*, 1990. p.56

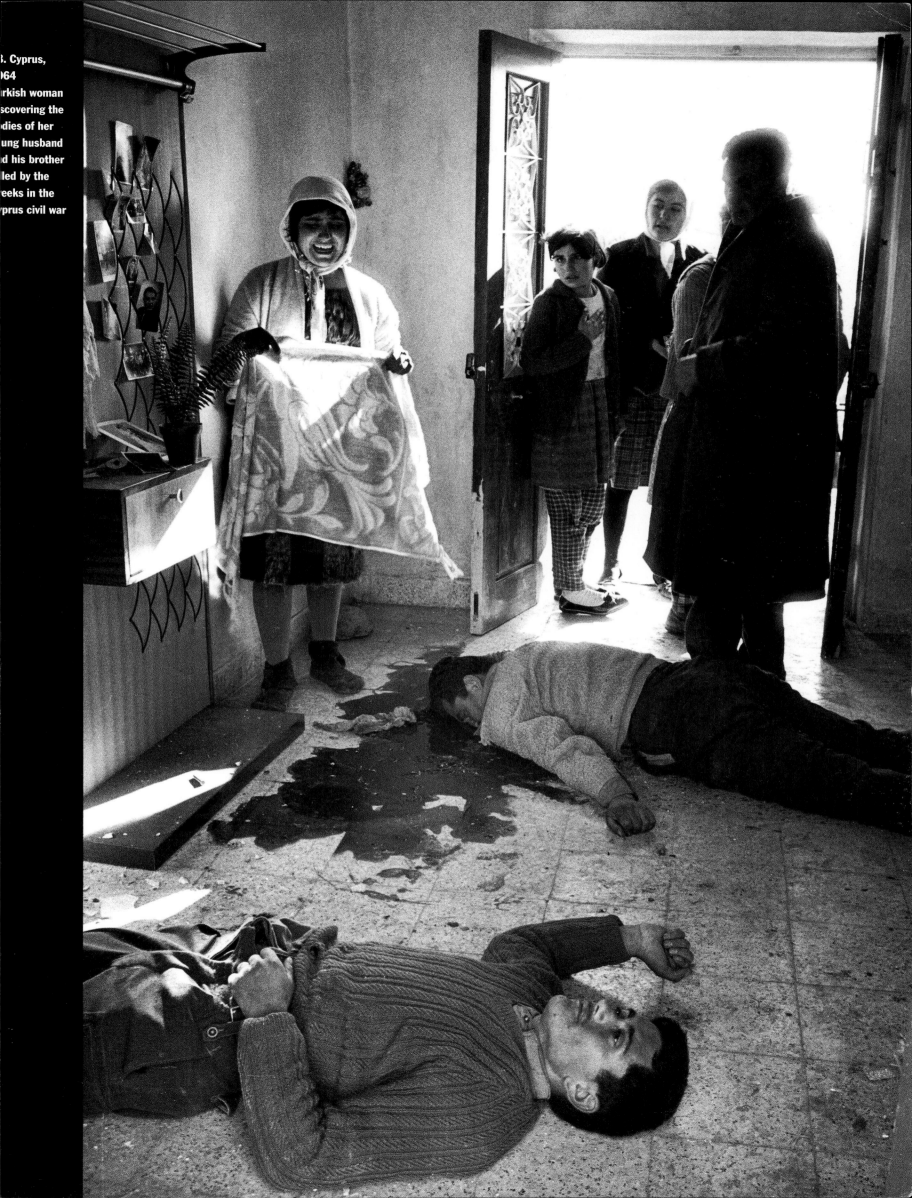

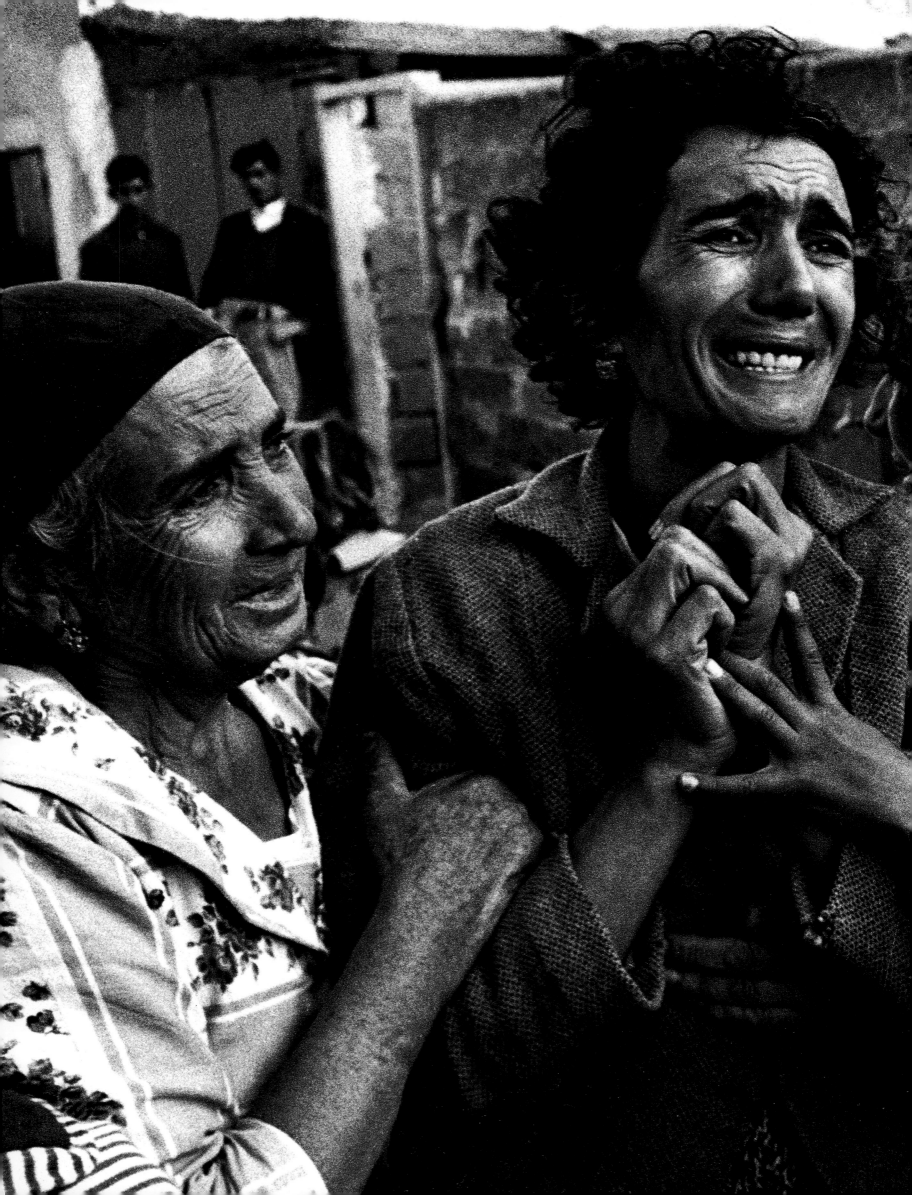

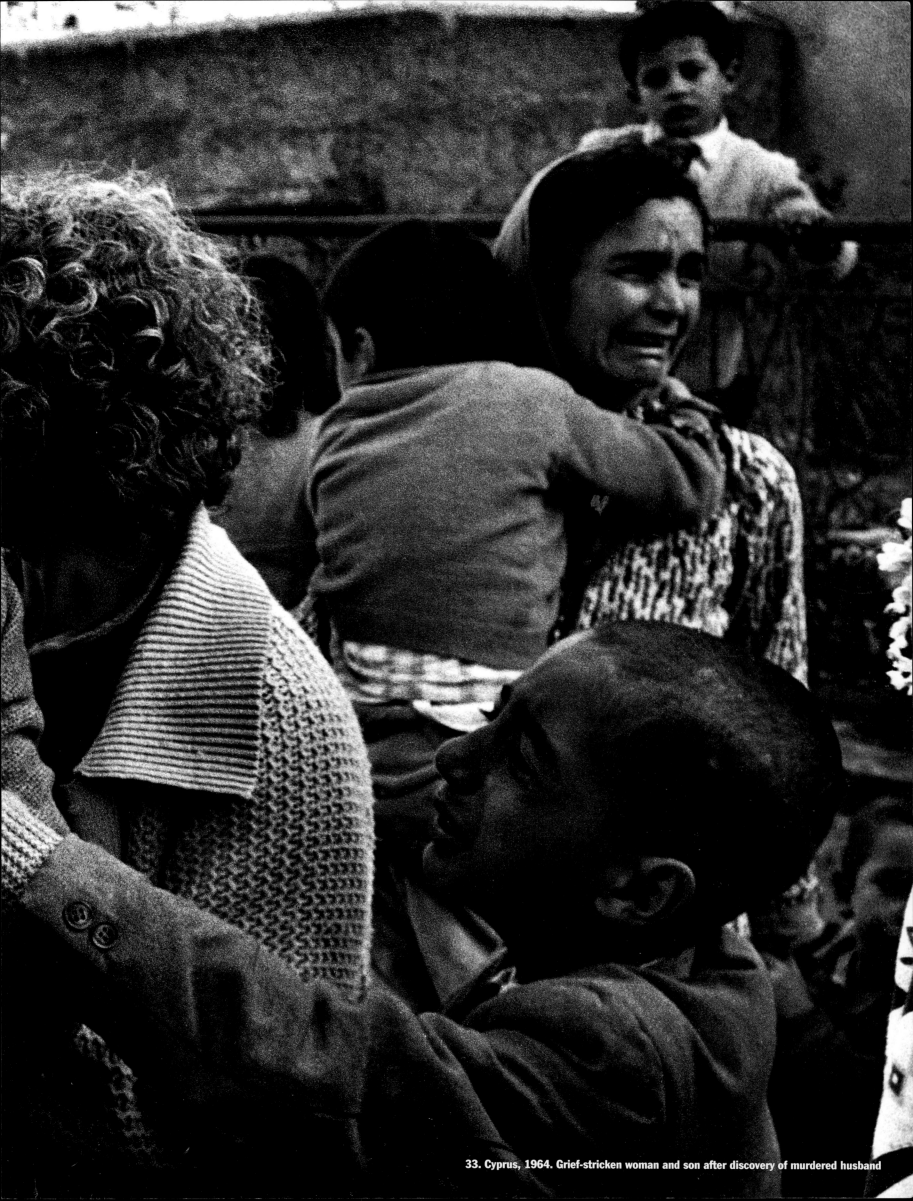

33. Cyprus, 1964. Grief-stricken woman and son after discovery of murdered husband

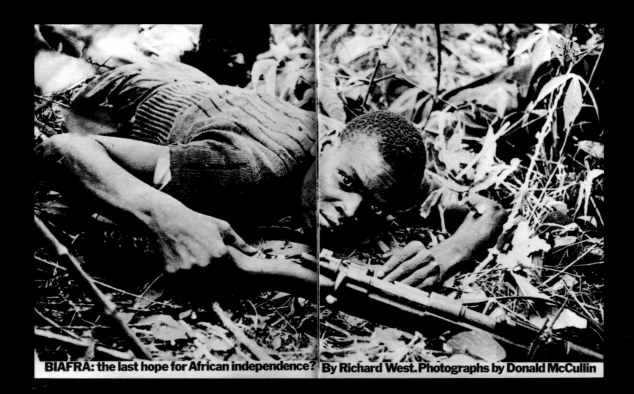

BIAFRA: the last hope for African independence? By Richard West. Photographs by Donald McCullin

Biafra, at the time I left, was faced with a danger of final annihilation... but Biafra is more than a human tragedy. Its defeat, I believe, would mark the end of African Independence.

Richard West. *The Sunday Times Magazine*, 1 June 1969

I think it does stand out as one of the most awful times that I've ever stood in front of a child. I walked into a camp in Biafra and there were 800 children waiting to die..."

Don McCullin. Interview with Pam Roberts, February 1991

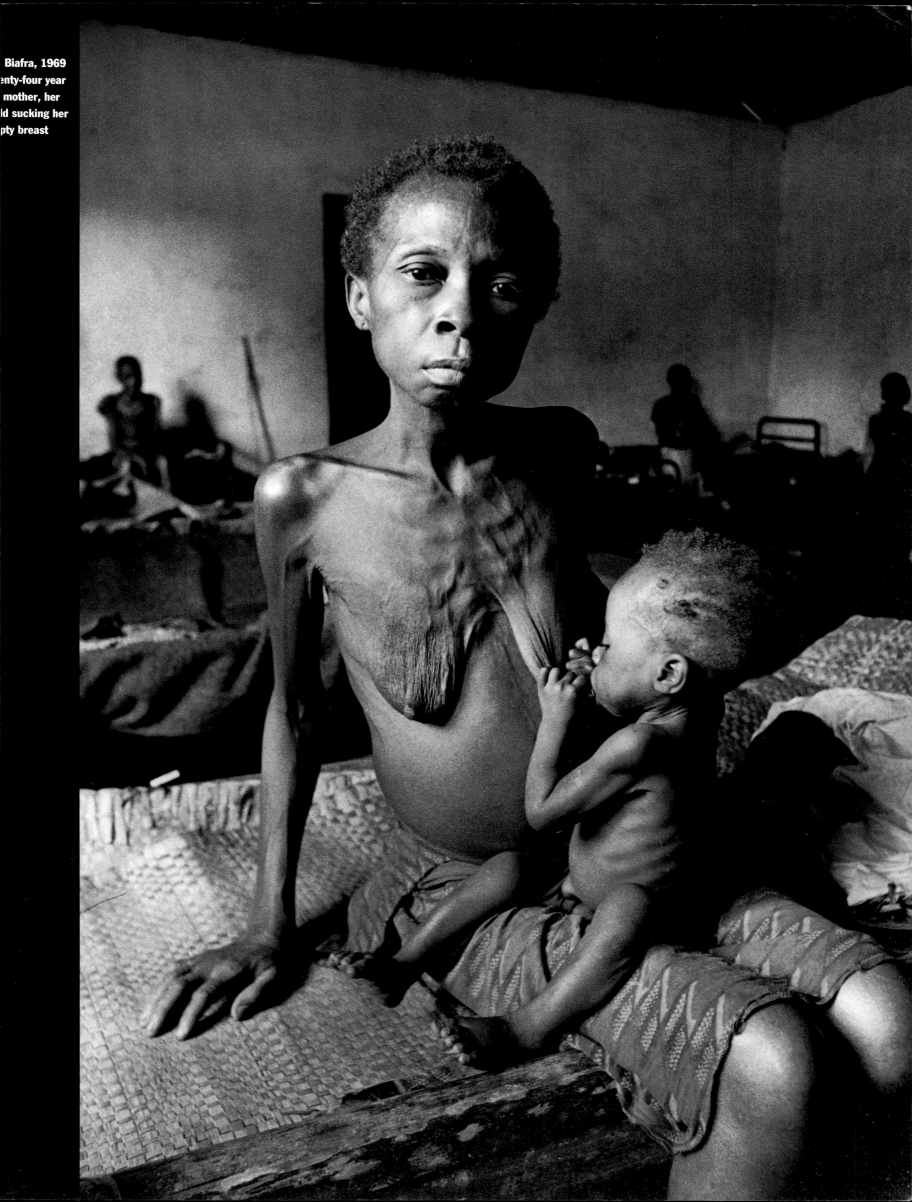

Biafra, 1969
enty-four year
mother, her
ld sucking her
pty breast

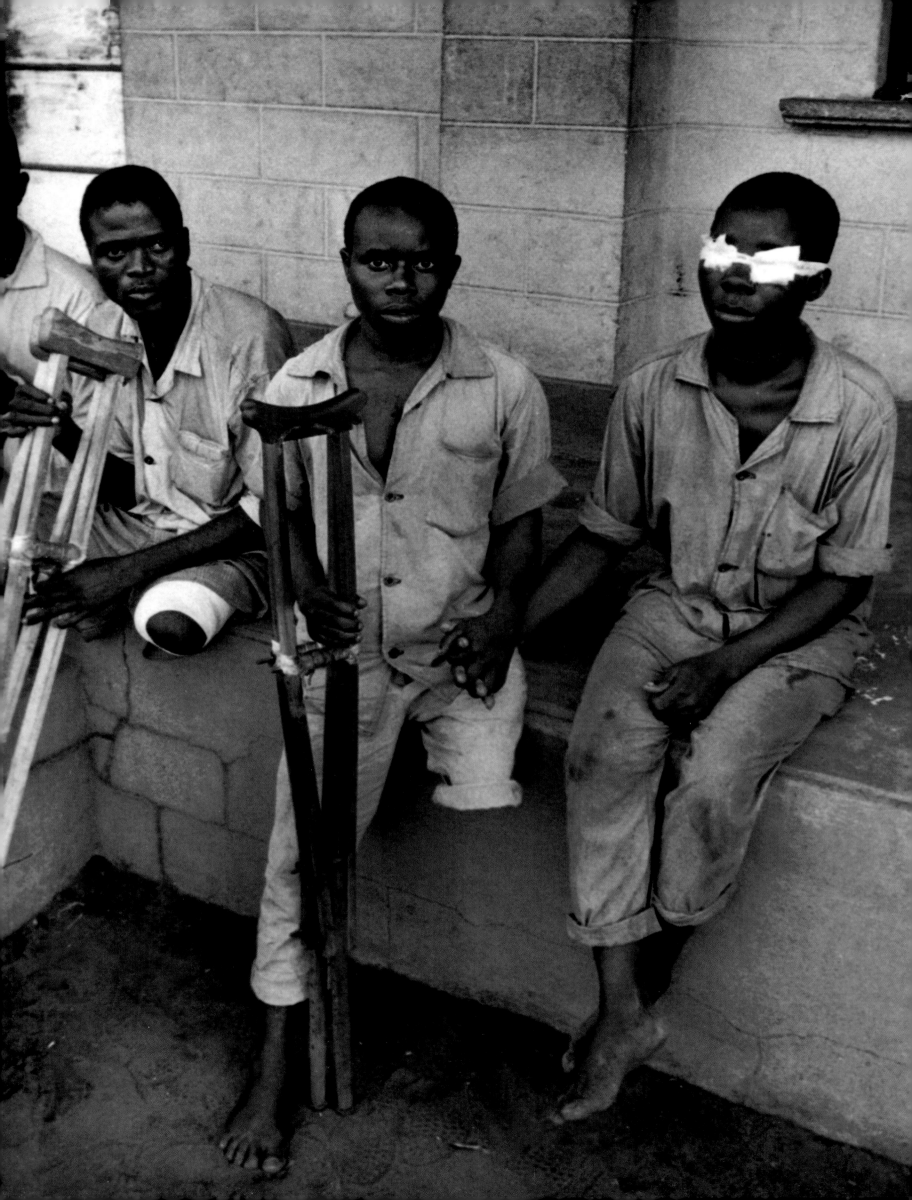

The demand for mercenaries – who are paid up to £800 a month to train Royalist tribesmen in the Yemen – is growing. A special organisation, "Le Groupe Experts Volontaires" has been formed in Paris to recruit veterans, and a Wolverhampton businessman plans to do the same thing in Britain.

Michael Mann. Mercenaries. *Town*, May 1965

I flew into the Congo with a great deal of nervous apprehension. I had heard much that was sinister about this once cannibal area. Joseph Conrad called it the Heart of Darkness.

Don McCullin. *Unreasonable Behaviour*, 1990. p.67

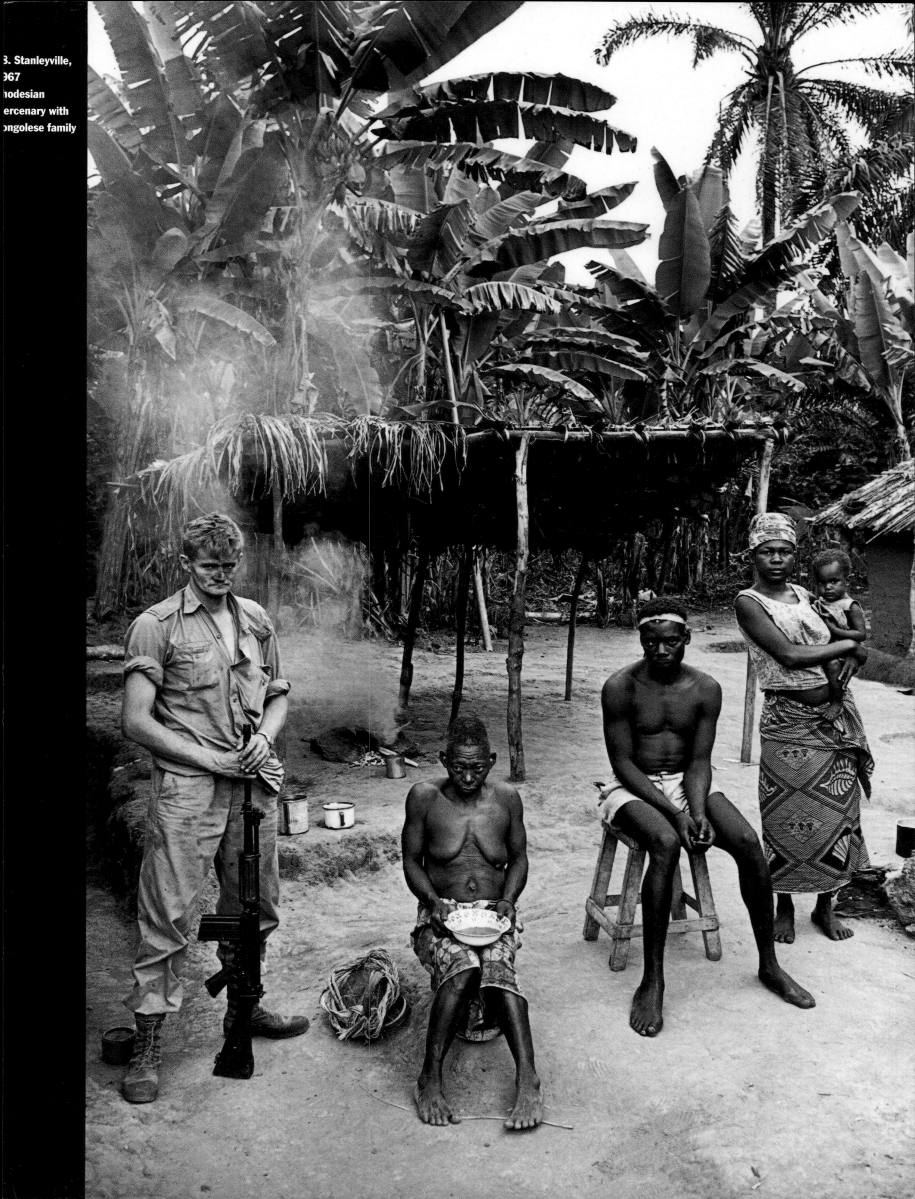

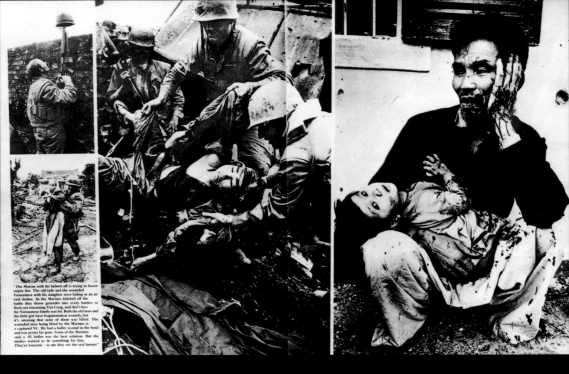

"The Marine with his helmet off is trying to locate sniper fire. The old lady and the wounded Vietnamese with his daughter were hiding in an air raid shelter. As the Marines finished off the battle they threw grenades into every bunker to flush out remaining Viet Cong, and that's how the Vietnamese family was hit. Both the old man and the little girl have fragmentation wounds, but it's amazing that none of them was killed. The wounded man being lifted by the Marines is a captured VC. He had a bullet wound in the head and was pretty far gone. Some of the Marines said a .45 bullet was the best solution. But the medics wanted to do something for him. They're fantastic – to me they are the real heroes"

The wounded man being lifted by the Marines is a captured VC, he had a bullet wound in his head and was pretty far gone. Some of the Marines said a .45 bullet was the best solution. But the medics wanted to do something for him. They're fantastic – to me they are the real heroes.

Don McCullin. *The Sunday Times Magazine*, 24 March 1968

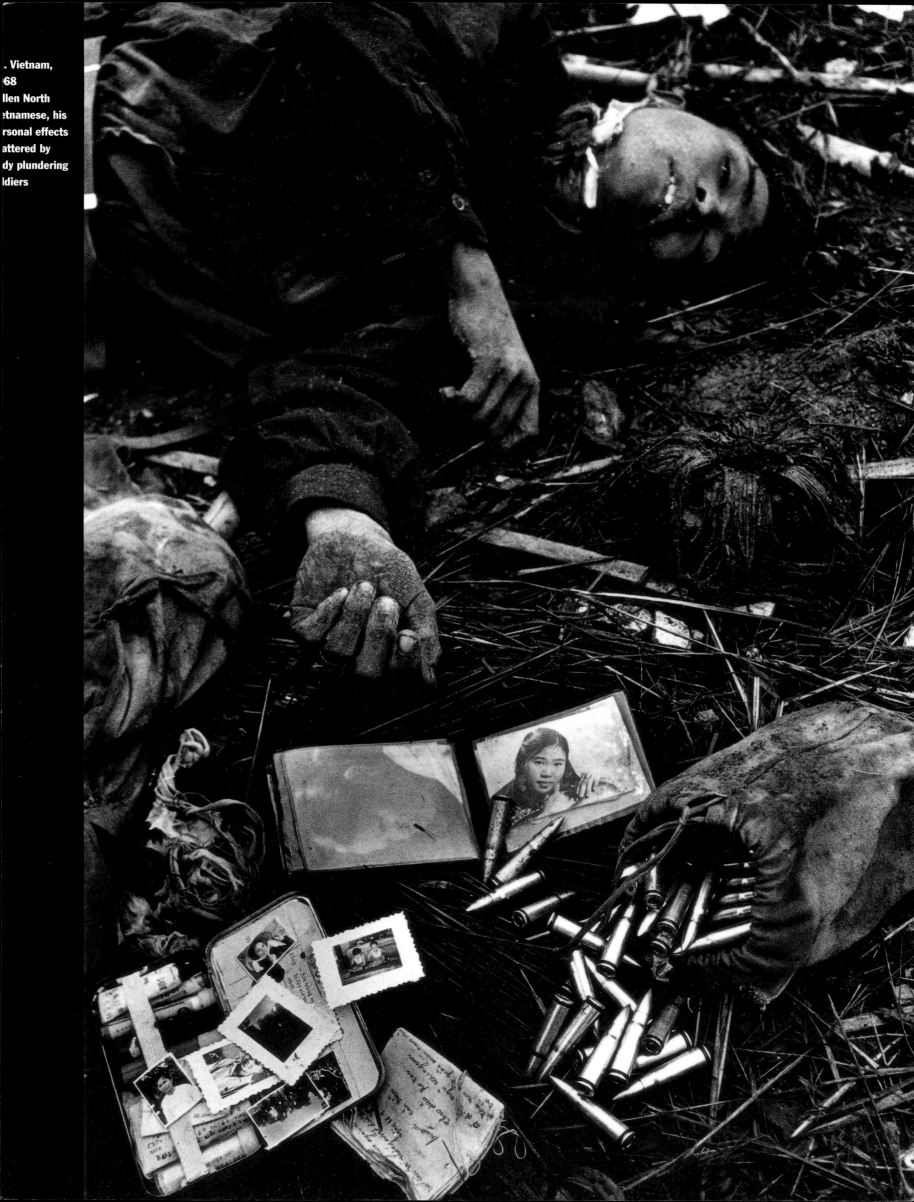

. Vietnam,
68
llen North
etnamese, his
rsonal effects
attered by
dy plundering
ldiers

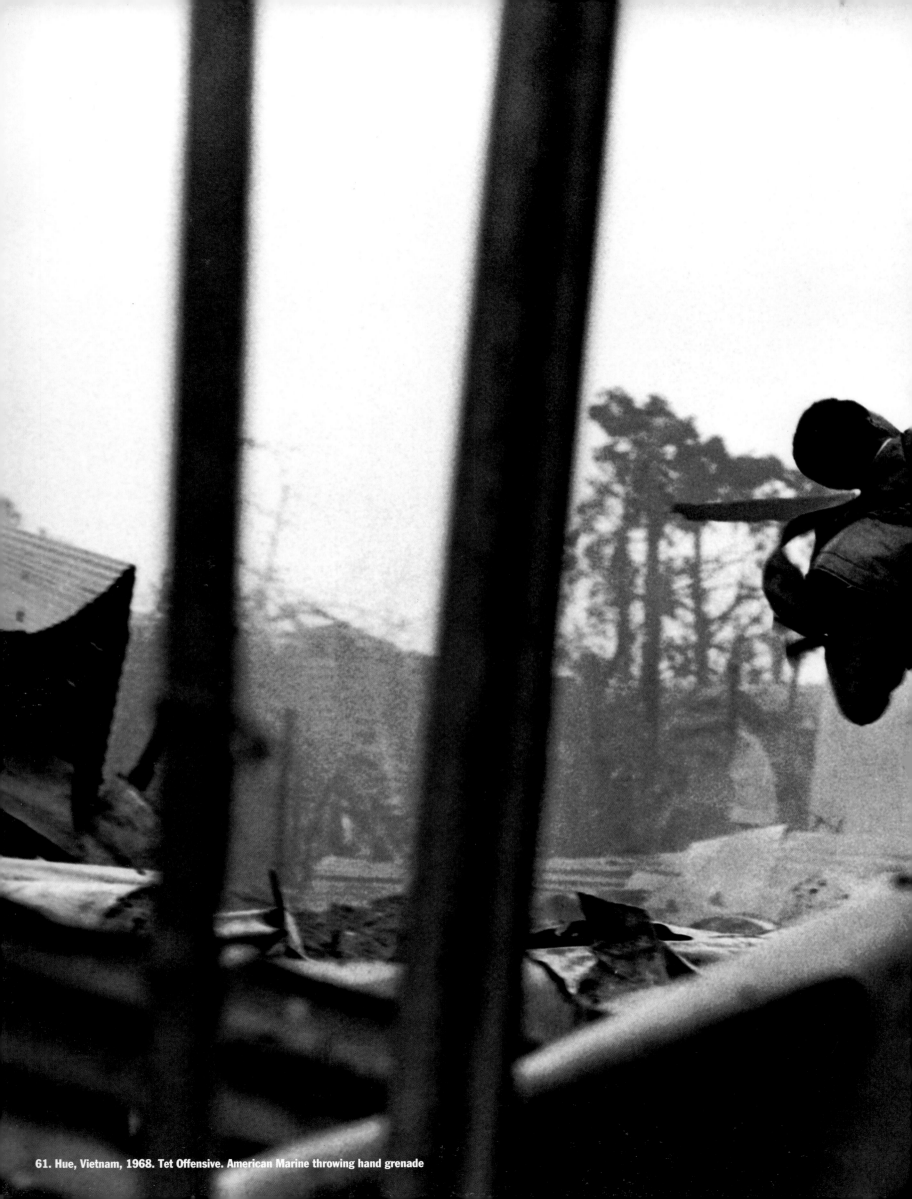

61. Hue, Vietnam, 1968. Tet Offensive. American Marine throwing hand grenade

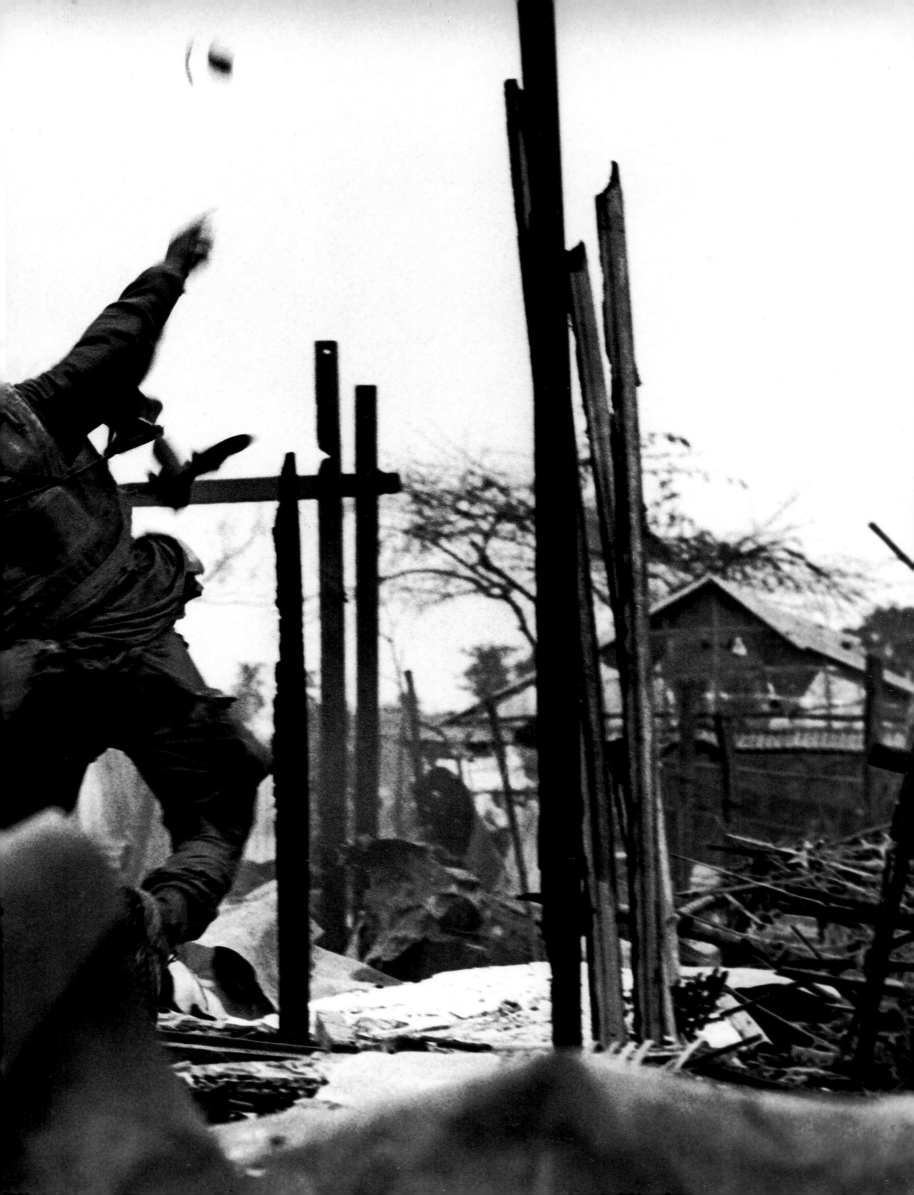

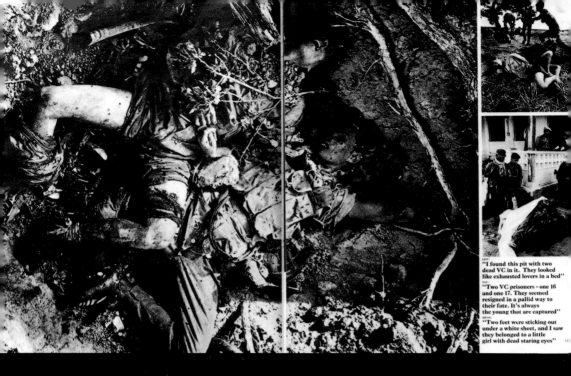

"I found this pit with two
dead VC in it. They looked
like exhausted lovers in a bed"

"Two VC prisoners - one 16
and one 17. They seemed
resigned in a pallid way to
their fate. It's always
the young that are captured"

"Two feet were sticking out
under a white sheet, and I saw
they belonged to a little
girl with dead staring eyes"

...I thought I'd have a walk over and see that
dead VC and it was then I found this pit with two
dead men it it. They looked like exhausted lovers
in bed. The man on the left had his leg blown
away and had crudely tried to bandage it. To the
others these men were just part of the "body
count"...

Don McCullin. *The Sunday Times Magazine*, 12 july 1970

Yet despite the ever-present danger to them,
correspondents still thronged to Cambodia and
its capital Phnom Penh. Before it was touched by
war it was always said to be an exquisite place.

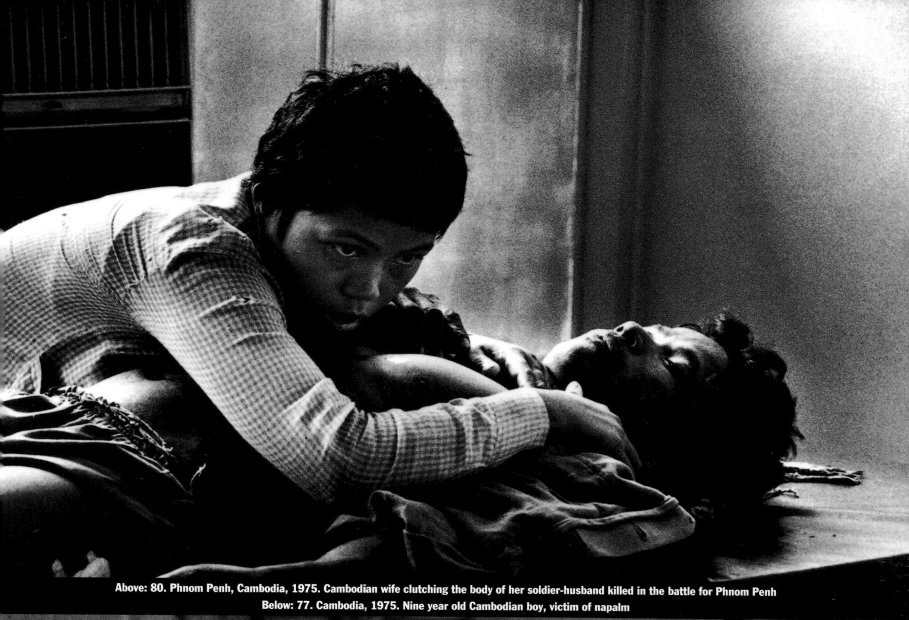

Above: 80. Phnom Penh, Cambodia, 1975. Cambodian wife clutching the body of her soldier-husband killed in the battle for Phnom Penh
Below: 77. Cambodia, 1975. Nine year old Cambodian boy, victim of napalm

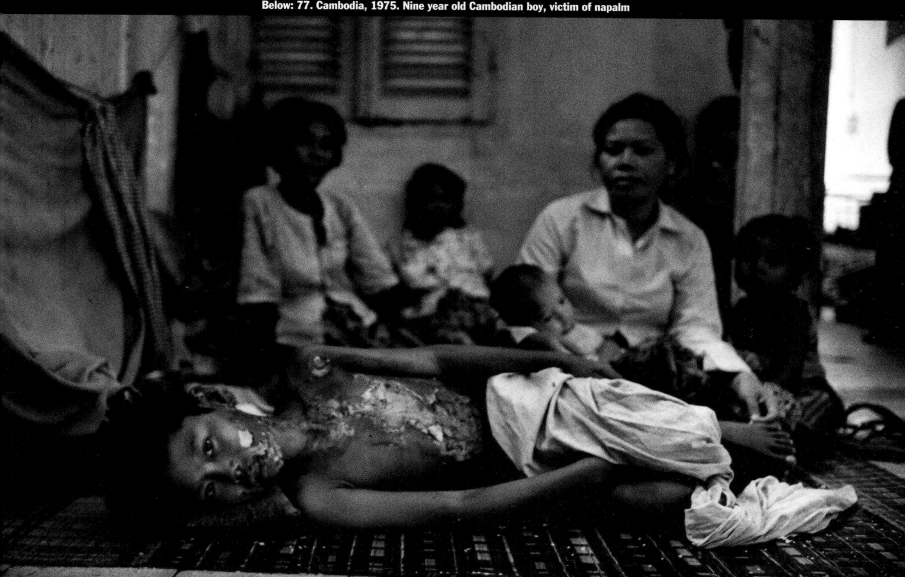

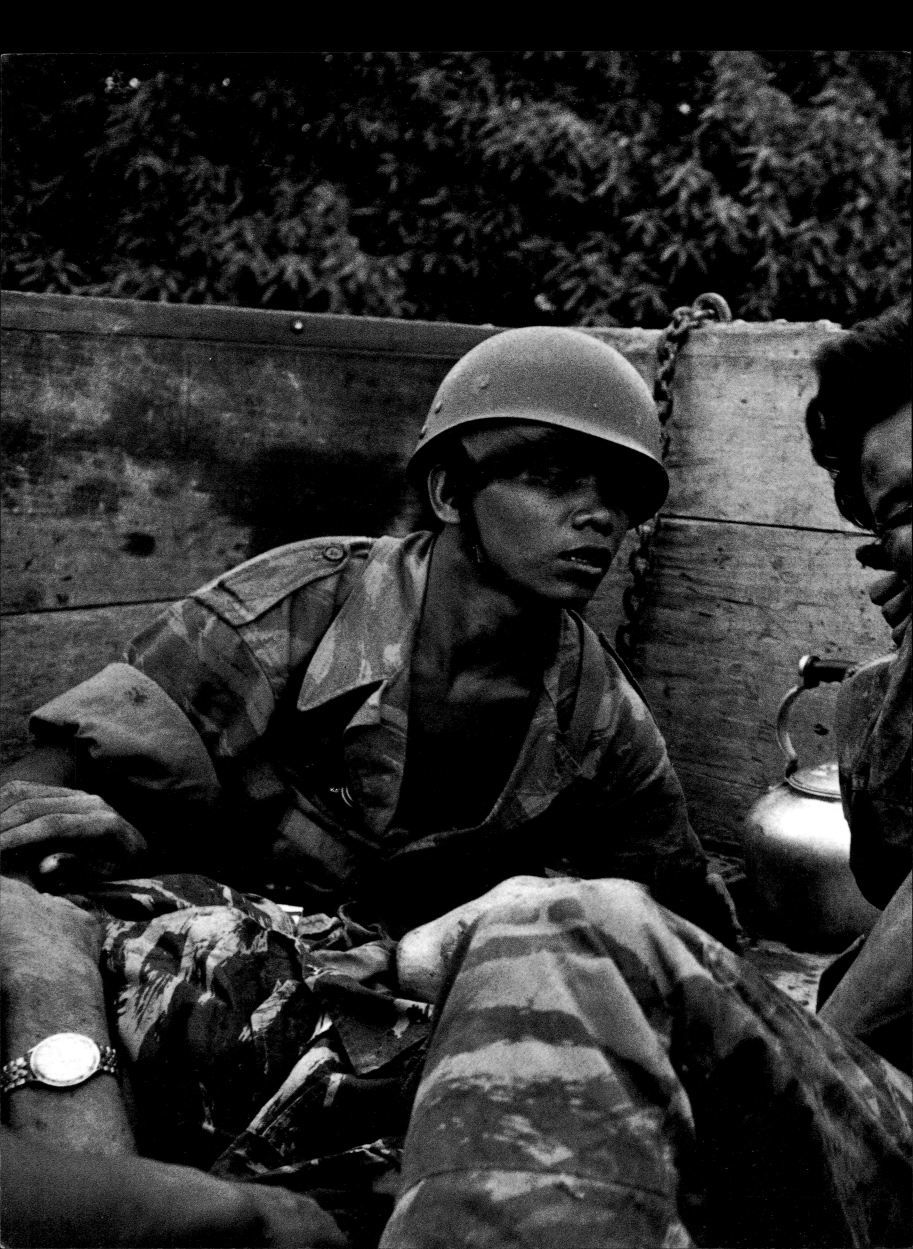

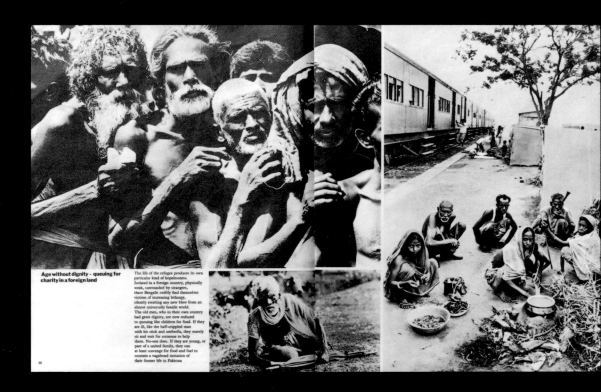

These are the world's newest refugees – nearly two million of them, who fled miles into India after civil war broke out in East Pakistan last March...

Nicholas Tomalin. *The Sunday Times Magazine*, 6 June 1971

By the time I got to the little cluster of huts that marked the settlement of thousands of refugees, the monsoon was raging, and its effect was more devastating than anything I could have imagined. Husbands were carrying dead wives and I could see men and women carrying dead children. There were virtually no medical supplies and within twenty-four hours of the monsoon starting, a cholera epidemic had broken out.

Don McCullin. *Unreasonable Behaviour*, 1990. p.63

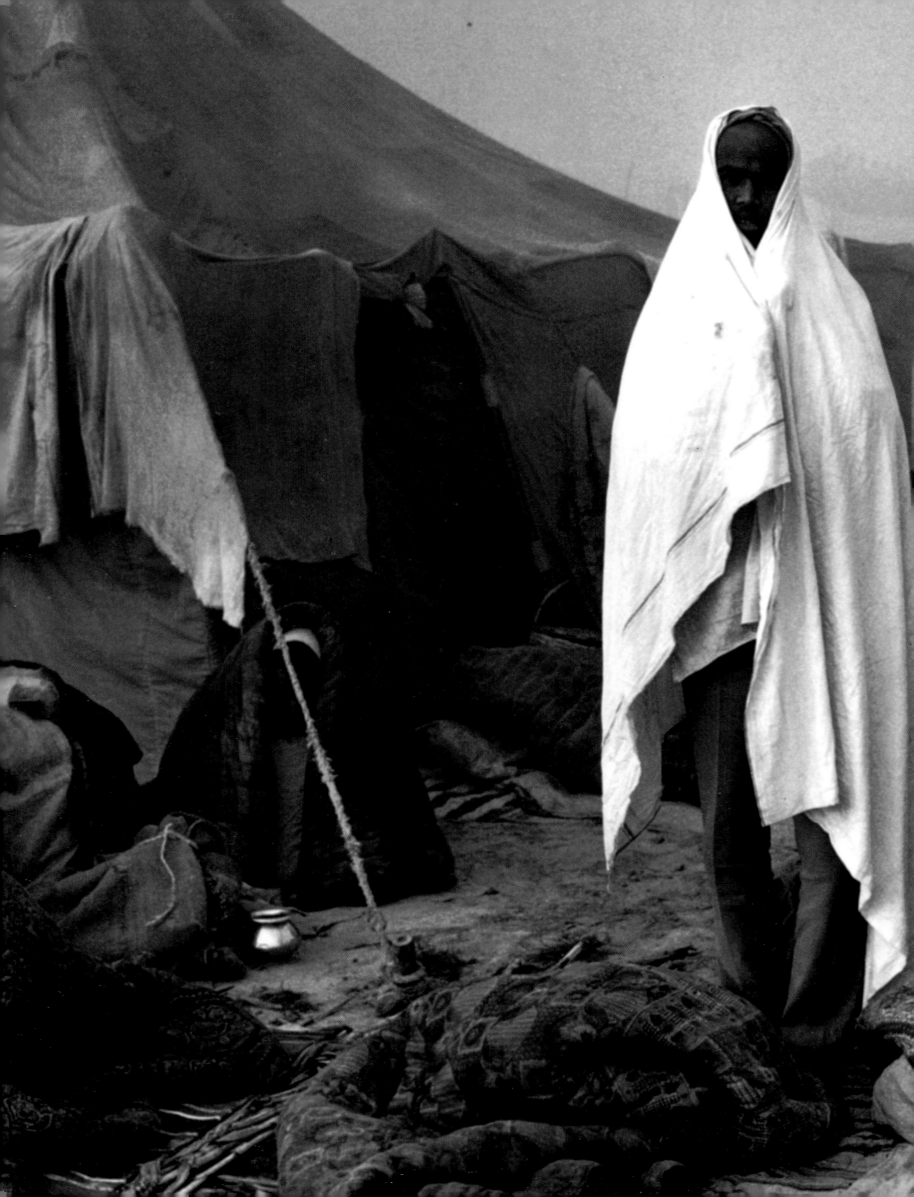

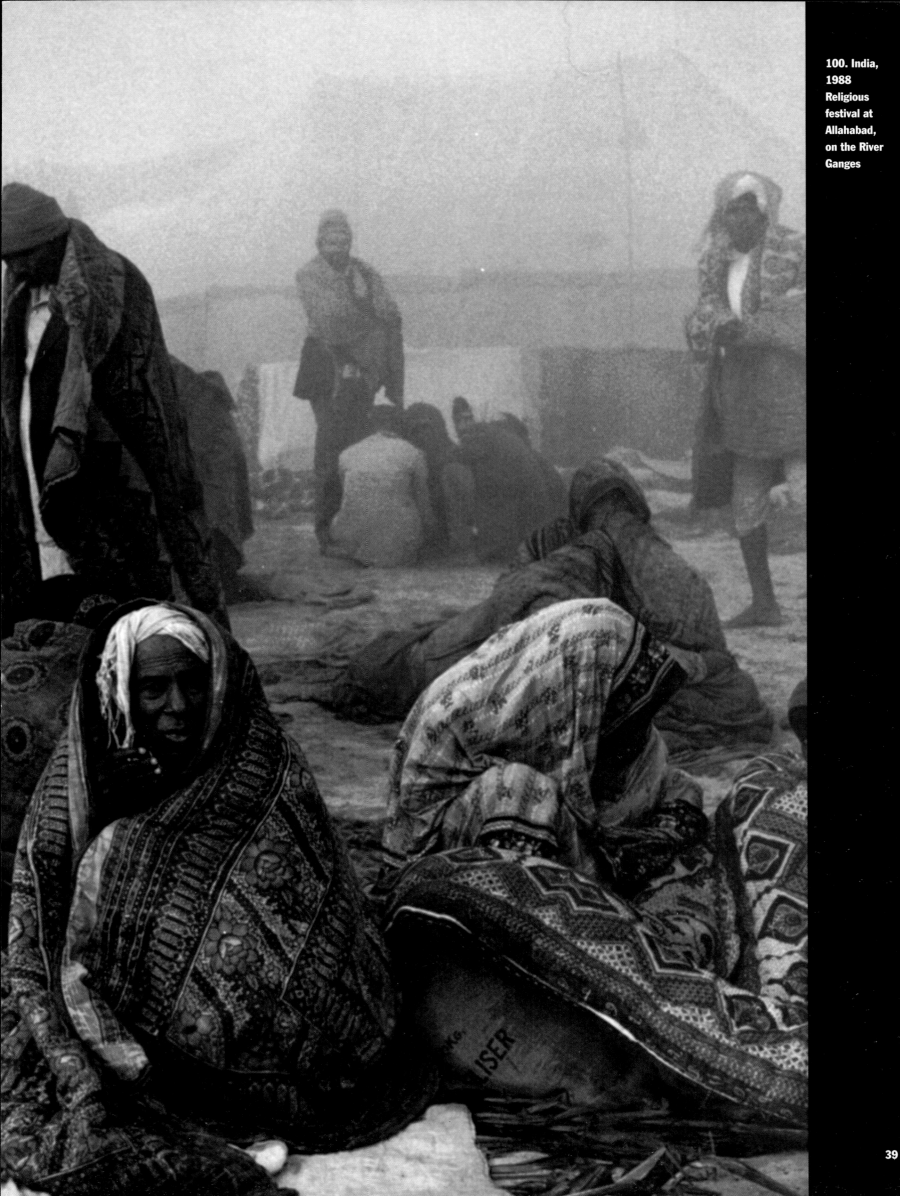

100. India,
1988
Religious
festival at
Allahabad,
on the River
Ganges

OPEN SKIES

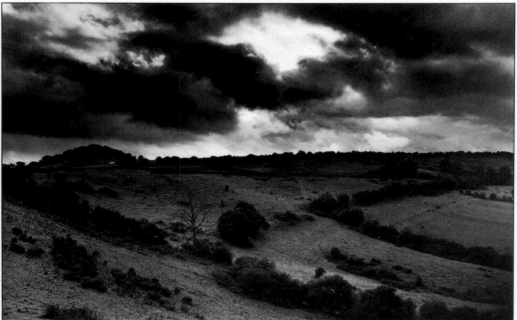

DON McCULLIN
Introduction by John Fowles

Don spoke strangely this last summer of longing
for autumn and winter, when the great Atlantic
storms start charging in from the west and up
the Bristol Channel, when he could go out ("like a
predator" he said) and once again photograph
the war in the skies that for him so potently sym-
bolizes, with its darknesses, its glints of light, the
greater war elsewhere. The parallels he suggests
between these landscapes and the human condi-
tion will be counted unnecessarily clouded and cruel
only by those penned up inside the sentimental
old tourist board picture of rural England...

John Fowles. Introduction to *Open Skies*, 1989

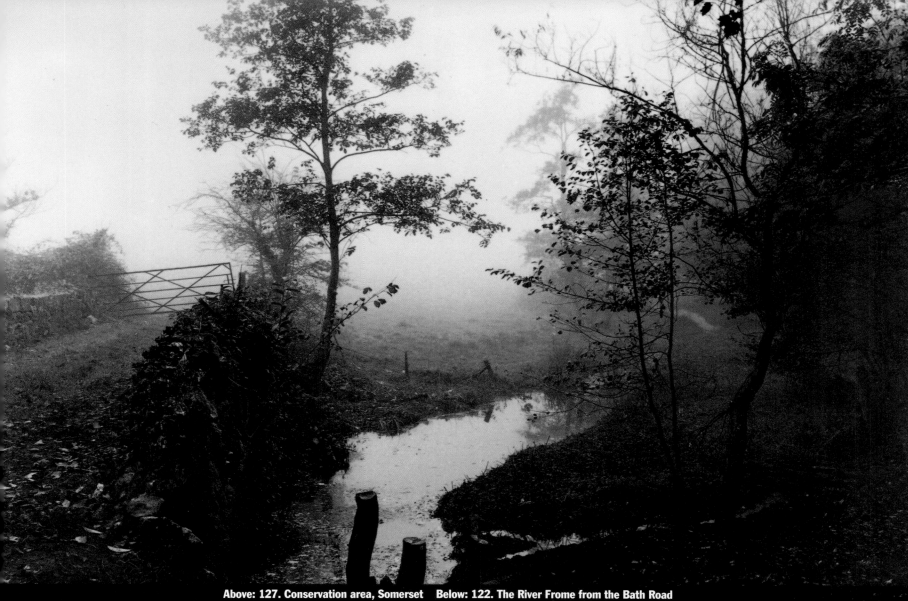

Above: 127. Conservation area, Somerset Below: 122. The River Frome from the Bath Road

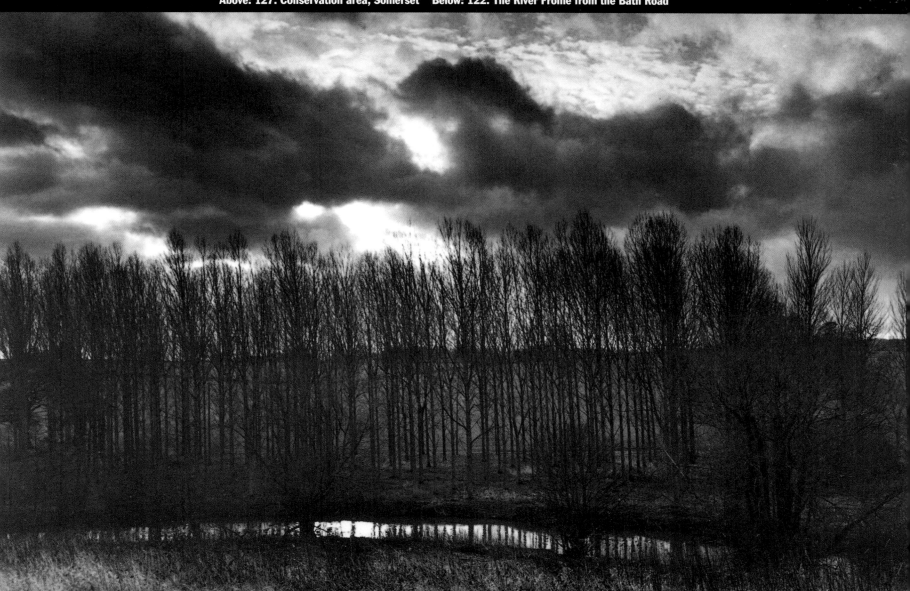

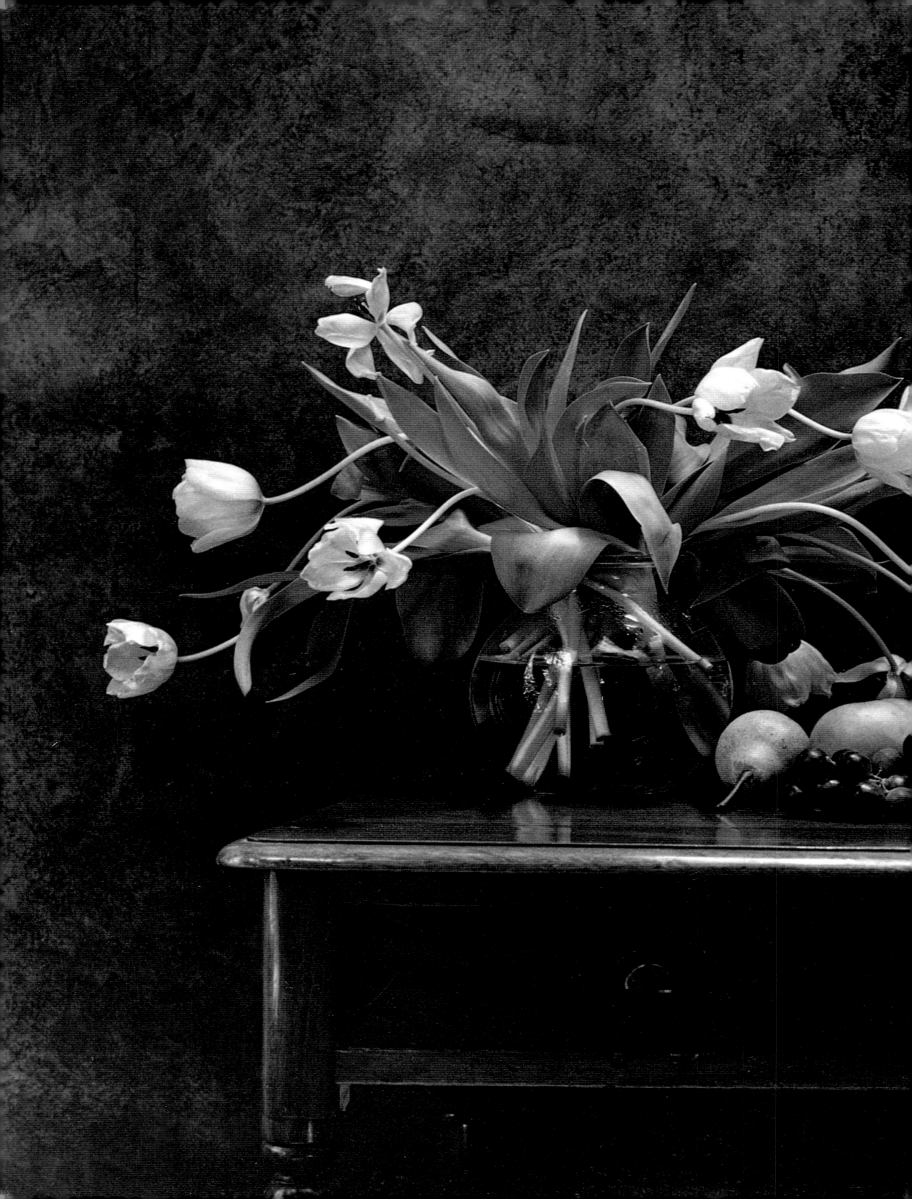

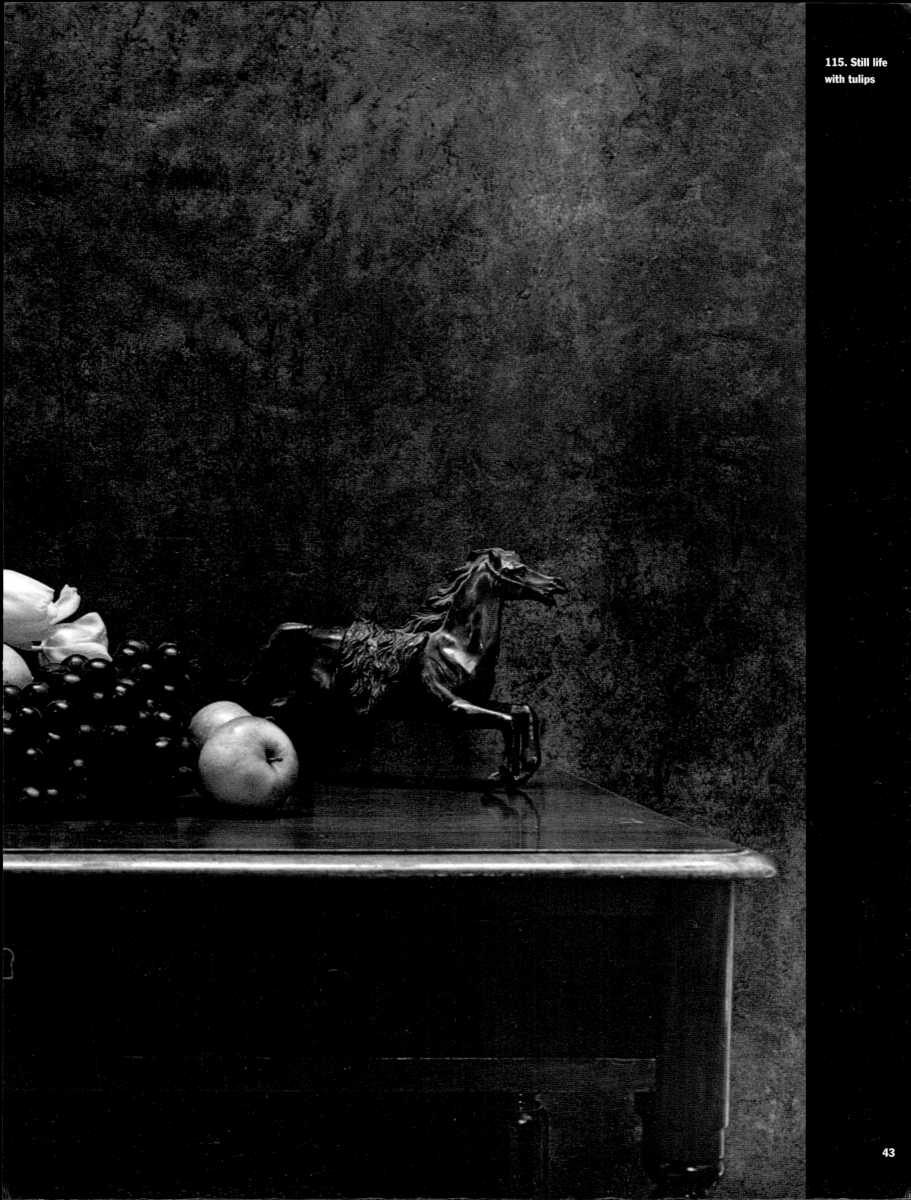

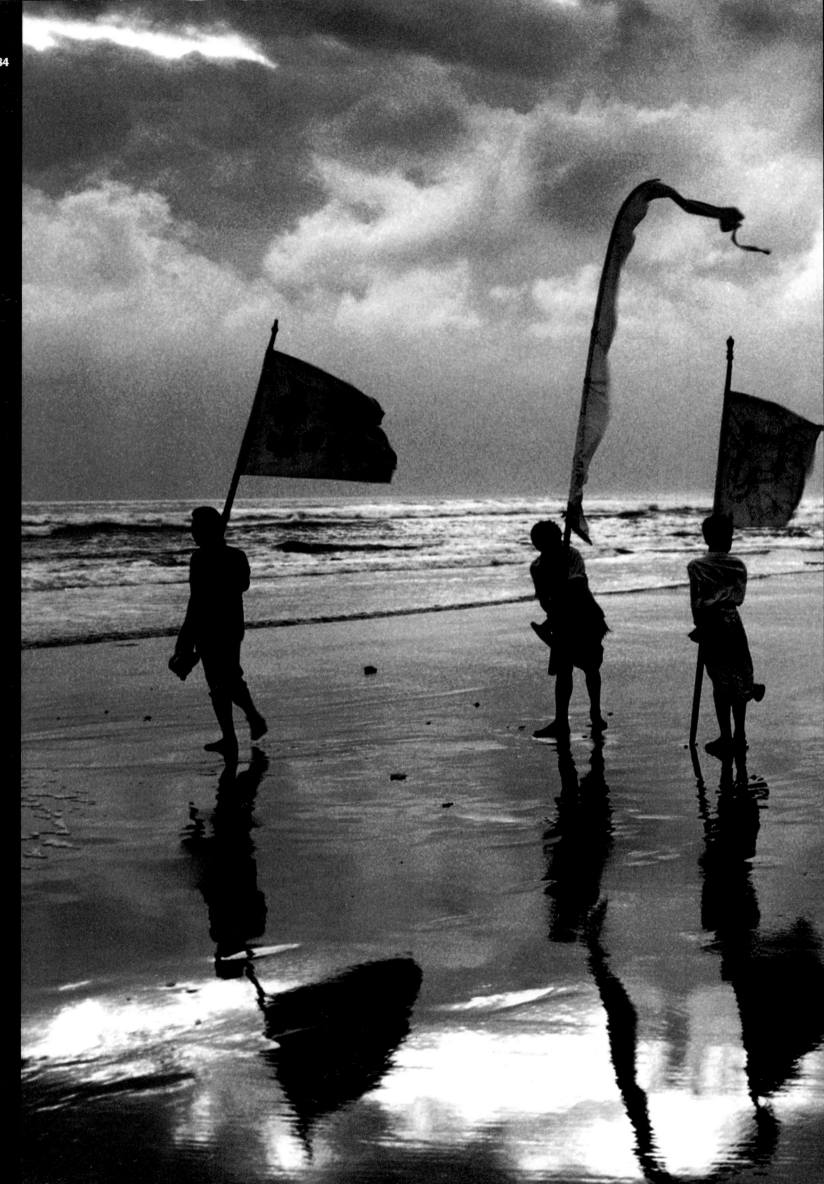

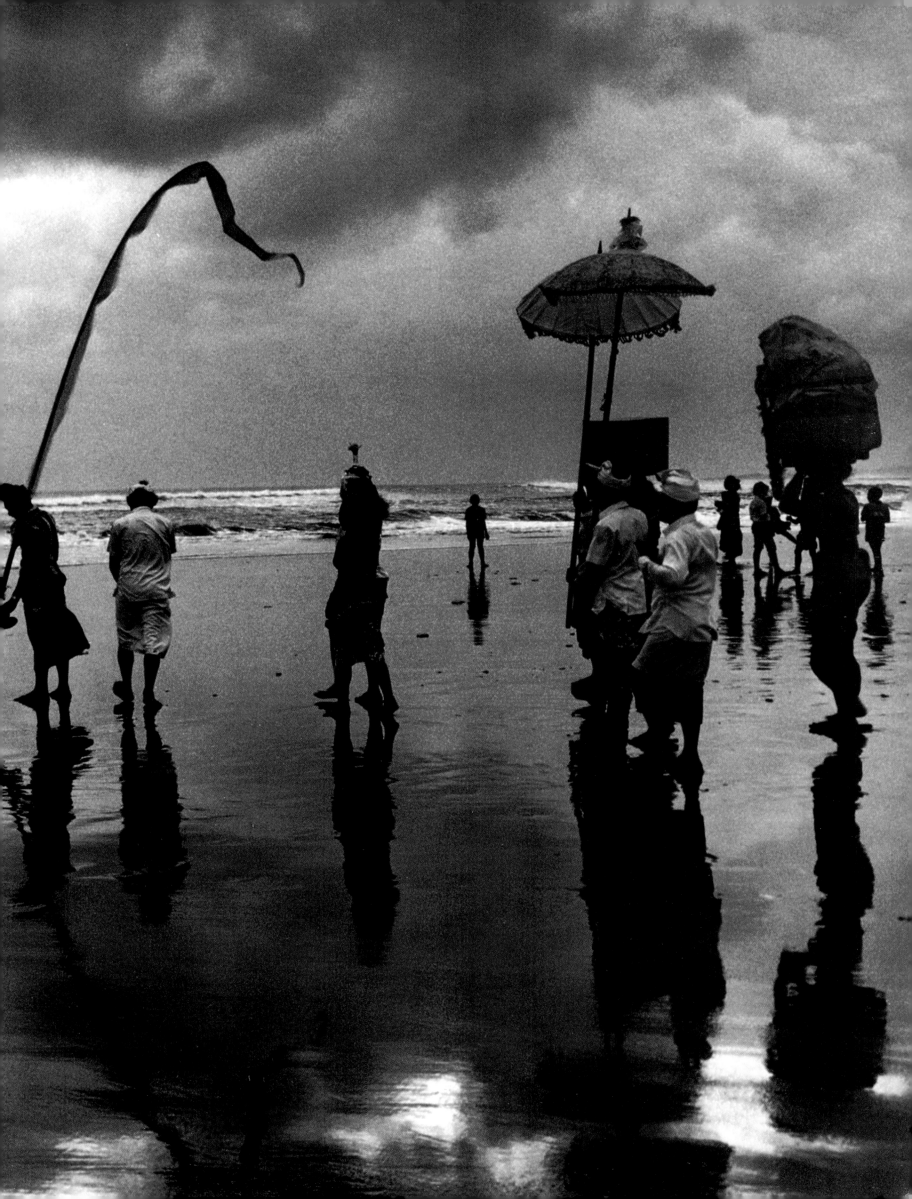

LIST OF WORKS

United Kingdom

1. Londonderry, N. Ireland 1970
British soldiers dressed like Samurais charge stone-throwing youths.

2. Bradford 1978
Mother and son in their kitchen

3. Liverpool, 1978

4. Fishermen playing football, Scarborough, 1968

5. Rhyl, 1968

6. Lumb Lane, Bradford, 1978
A man on crutches making his way home during a winter rain storm

7. Bradford, 1978

8. Bradford, 1978.
Children in slum housing

9. East End, London, 1973
Destitute and lonely woman

10. West Hartlepool, 1963
Steelworks, winter

11. East End, London, 1973
Destitute man

12. East End, London, 1973
Destitute man

13. Sunderland, 1964
Man with sacks of coal going home, winter

14. East End, London, 1973
Destitute men gather round a fire

15. East End, London 1973
Portrait of Irish down-and-out, lonely and hungry but not without dignity

16. West Hartlepool, 1963
Man going to early shift, steel works, winter

17. Bradford, 1978
Boy whose leg was mutilated in a scrapyard accident and whose only mode of transport was a baby's pram

18. Trafalgar Square, London, 1963
Anti-fascist riots

19. Finsbury Park, London, 1958
McCullin's first photograph

20. Hornsey Road, Finsbury Park, London, 1958
Italian Cafe

21. Finsbury Park, London, 1958
"The Guv'nors" street gang in derelict house

22. Hornsey Road, Finsbury Park, London, 1958
Italian Cafe, meeting place of street gangs

23. Spitalfield Market, London, 1973
Down-and-out shouting confused political obscenities

24. Southend, 1966

25. East End, London, 1973
Down-and-out sleeping in the rain and waiting for death (which came)

Cyprus and Beirut

26. Cyprus, 1965
Turkish boy with his dead father

27. Cyprus, 1964
Turks reaching out for the body of an old man shot during the battle for Limassol

28. Cyprus, 1964
Turkish woman discovering the bodies of her young husband and his brother killed by the Greeks in the Cyprus civil war

29. Cyprus, 1964
A Turkish defender running from the cinema in Limassol

30. Sabra camp, Lebanon, 1982
Palestinian woman after the massacre

31. Quarantina, Beirut, 1975
Palestine Liberation Organisation training camp

32. Beirut, 1982
Lebanese family emerging from the Matryrs cemetery, having buried a relative

33. Cyprus, 1964
Grief-stricken woman and son after discovery of murdered husband

34. Cyprus, 1964
Turkish woman with dead body of her young husband, killed by the Greeks in Cyprus civil war

35. Quarantina, Beirut, 1975
Christian militia mock the body of a dead girl killed in the battle of Quarantina

36. Beirut, 1976
Christian Phalange gunmen crawling through the reception lobby of the Holiday Inn Hotel during the civil war

37. Chatila, Beirut, 1982
Palestinian woman, her home destroyed by the Christian Phalange

38. Quarantina, Beirut, 1975
Palestinian women after massacre by Christian Phalange

Biafra

39. Biafra, 1969
Sixteen year old, mentally handicapped, starving, and with little chance of survival, begging for food

40. Biafra, 1969

41. Biafra, 1970
Biafran family waiting in food distribution area. They were eventually driven away by soldiers

42. Biafra, 1970
Albino boy, not only starving and at death's door, but ridiculed by fellow sufferers for his skin pigmentation

43. Biafra, 1970
Close-up of a nine year old boy waiting in food queue

8. Bradford, 1978. Children in slum housing

44. Biafra, 1969
Twenty-four year old mother, her child sucking her empty breast

45. Biafra, 1970
A camp of misery: eight hundred children, dying of hunger and disease, awaiting their turn for death

46. Biafra, 1970
Two starving boys waiting in vain for food. (They were in fact, chased away by soldiers with sticks)

47. Biafra, 1970
A new baby born in the night. The mother waits in hope of medical attention to cut the umbilical cord and receive food. She received neither

48. Biafra, 1970
A beautiful and dignified girl of sixteen in a death camp in Biafra

49. Biafra, 1969

50. Biafra, 1969
Battle fatigued Biafran officer talking to dead soldier

51. Biafra, 1969
Soldiers carrying away the body of a comrade from the front

52. Biafra, 1969
Crippled and maimed soldiers wait for food handouts at a Catholic mission

53. Biafra, 1969
Soldier receiving treatment for bullet wound in the face

54. Biafra, 1969
Biafran soldier rushing wounded comrade from the front

Africa and Congo

55. Congo, 1964
Congolese soldiers tormenting prisoners before their execution in Stanleyville

56. Congo, 1964
Congolese soldiers tormenting prisoners before their execution in Stanleyville

57. Congo, 1964
Congolese soldiers ill-treating prisoners awaiting death in Stanleyville

58. Stanleyville, 1967
Rhodesian mercenary with Congolese family

59. Zimbabwe, 1981
Guerrilla leader mustering forces at a monitoring point prior to the laying down of arms

Vietnam and Cambodia

60. Hue, Vietnam, 1968
North Vietnamese soldier, found after lying in a bunker for three days

61. Hue, Vietnam, 1968
Tet Offensive
American Marine throwing hand grenade

62. Vietnam, 1968
American Marines, "Like Hollywood"

63. Hue Vietnam, 1968
Vietnamese civilians injured by American hand grenades

64. Vietnam, 1968
Marine Officer with two bullet wounds looking for help

65. Vietnam, 1968
Marine with bullet wounds in both legs being supported

66. Hue, Vietnam, 1968
Marines running with badly wounded comrade against incoming explosions, dusk

67. Vietnam, 1968
Marine medic attending dying soldier hit by grenade

68. Vietnam, 1968
A Vietnamese civilian being tormented by his "liberators" American Marines

69. Hue, Vietnam, 1968
Marines tormenting Vietnamese civilian captured during the battle of Hue

70. Hue, Vietnam, 1968
Shell-shocked soldier awaiting transportation away from the front line, Hue

71. Vietnam, 1968
Fallen North Vietnamese, his personal effects scattered by body plundering soldiers

72. Praveng, Cambodia, 1970
Two Cambodian anti-tank gunners in action

73. Cambodia, 1970
A Cambodian soldier making his last protest of pain before dying

74. Vietnam, 1967
Vietnamese soldiers with a stolen duck during a search and destroy operation

75. Phnom Penh, Cambodia, 1975
Cambodian wife comforts her husband who has lost both legs in the battle for Phnom Penh

76. Phnom Penh, Cambodia, 1975
A wife and baby watch the agony of her husband lying in a hospital corridor

77. Cambodia, 1975
Nine year old Cambodian boy, victim of napalm

78. Phnom Penh, Cambodia , 1975
Cambodian boy at bedside of his injured mother, basketball stadium

79. Cambodia, 1970
Cambodian soldiers looking almost festive in their neck-scarves, mourn the death of a child in battle

80. Phnom Penh, Cambodia, 1975
Cambodian wife clutching the body of her soldier – husband killed in the battle for Phnom Penh

81. Phnom Penh, Cambodia, 1975
Cambodian soldier supporting his comrade who has just lost a foot in the battle for the city

82. Vietnam, 1968
Portrait of American Marine

83. Vietnam, 1968
Two marines tentatively exploring the body of a fallen North Vietnamese soldier for booby traps before plundering his personal effects

84. Vietnam, 1968
Wounded marine in need of medical attention

85. Mekong Delta, Vietman, 1968
Vietnamese village elder

86. Vietnam, 1968
Marine under sniper fire

India and Bangladesh

87. Bangladesh, 1971
Trying to cool the fever of a girl dying of cholera

88. India/Bangladesh border, 1971
Woman suffering from cholera being taken to hospital by local transport in monsoon weather

89. Bangladesh, 1971
A woman has just died of cholera: her family, dazed and heartbroken, gather together to share their loss

90. Bangladesh, 1971
The Dead Body Compound of a refugee camp: a man places his nine year old son next to the body of a one year old boy

91. India, 1965
Young Indian family

92. Delhi, India, 1965
Strange travellers – a destitute Tibetan family in the booking hall of the railway station at dawn

93. Bangladesh, 1971
Exhausted father and young baby fleeing from Bangladesh war separated from their own family

94. Bangladesh, 1971
Exhausted refugee mother and child

95. India, 1971
Bangladeshi man carrying sick wife, suspected of having cholera, across border into makeshift hospital

India – Animal Fair and Religious Festival

96. India, 1988
Religious festival at Allahabad, on the River Ganges

97. The Sonepur Mela, India, 1990
Kartik Purnima, the Festival of the Full Moon. Animal fair and religious festival

98. The Sonepur Mela, India, 1990
Kartik Purnima, the Festival of the

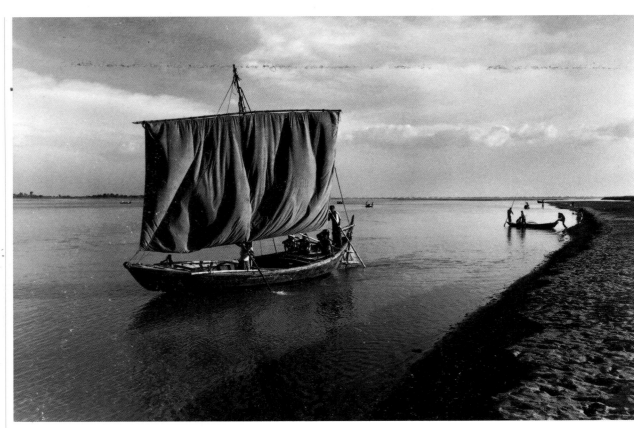

105. India, 1988. Sailboat on the River Gandak